Jacob Lawrence

Jacob Lawrence

by Milton W. Brown

with the assistance of Louise A. Parks

WHITNEY MUSEUM OF AMERICAN ART, NEW YORK

Distributed by Dodd, Mead & Company, New York

Copyright © 1974 by the Whitney Museum of American Art,
945 Madison Avenue, New York, N. Y. 10021
ISBN: 0-396-06986-X
Library of Congress Catalogue Card Number: 74-78123
Designed by Joseph Bourke Del Valle
Printed in the United States of America by S. D. Scott Printing Company, Inc.
Photographs by Geoffrey Clements, Peter A. Juley & Son,
Walter Rosenblum, John D. Schiff.

JACOB LAWRENCE

An exhibition of his work
Sponsored by IBM Corporation
Organized by the Whitney Museum of American Art

We feel it particularly fitting that Jacob Lawrence's leadership
in painting be honored by a museum which is itself a leader
in the contemporary field—the Whitney Museum of American
Art. IBM is privileged to have helped make this exhibition
possible through a public service grant to the Museum.

<div align="right">

Frank T. Cary
Chairman of the Board
IBM Corporation

</div>

Whitney Museum of American Art, New York
 May 16 - July 7, 1974
The St. Louis Art Museum, Missouri
 August 1 - September 1, 1974
Birmingham Museum of Art, Alabama
 September 23 - October 23, 1974
Seattle Art Museum, Washington
 November 15 - December 15, 1974
William Rockhill Nelson Gallery of Art and
Atkins Museum of Fine Arts, Kansas City, Missouri
 January 6 - February 6, 1975
New Orleans Museum of Art, Louisiana
 February 27 - March 29, 1975

Acknowledgments

This publication was compiled for the Jacob Lawrence exhibition held at the Whitney Museum of American Art, May 1974.

I am grateful to John I. H. Baur, Director of the Whitney Museum of American Art, for offering me the opportunity to serve as guest curator of the Jacob Lawrence exhibition. It has been a rewarding experience.

Any exhibition is a cooperative venture and I am deeply indebted to all who have collaborated in the realization of this one. Jacob Lawrence and his wife, Gwen, were very gracious in offering their memories and supplying much documentary material. I had a delightful time with both Charles Alston and Romare Bearden, who did their best to recall the youthful and exciting days of the '30s that they shared with Jacob Lawrence. The assembly of the exhibition was facilitated by the generous assistance of Charles Alan, who made available his extensive collection of photographs of Lawrence's work and the accumulated knowledge of many years of association with him. Lawrence's current dealer, Terry Dintenfass, and her assistant, Luise Ross, were of great help in locating pictures and collectors, supplying photographs and answering all kinds of questions. The Archives of American Art, which contains the Jacob Lawrence papers, has been an invaluable source of research material.

My greatest debt is to Louise Parks, a graduate student in the Doctoral Program in Art History at the City University of New York, who acted as my assistant and did most of the legwork and research in the compilation of the catalogue and bibliography. She was instrumental in locating the *Frederick Douglass* and the *Harriet Tubman* series and is still on the track of the missing *Coast Guard* paintings. We are grateful for the cooperation of Dorothy Younger, formerly of the Harmon Foundation; Melvin Jackson of the Smithsonian Institution; Mr. Baum of the United States Coast Guard Exhibition Center; Lt. Cmdr. Reid and Capt. Meaux of the USCG; Terry Carter of the USCG Public Information Office, and Mr. Dickson, Librarian of the USCG Academy.

The following have been most helpful in making collections available for study and selection: Abram Lerner of the Hirshhorn Museum and Sculpture Garden, Sara Mazo of The Museum of Modern Art, Richard Friedman and William de Loopel of The Phillips Collection, David C. Driskell of Fisk University, Julia R. Vodicka of Hampton Institute and Lawrence Curry of the Detroit Institute of Arts. Special thanks are extended to all the museums and private collectors who lent works to the exhibition.

Much of the detail in organizing the exhibition and producing the catalogue was ably handled by the staff of the Whitney Museum of American Art. I am grateful for the interest and dedication of Jacki Ochs in many aspects of the process; James Monte for the installation; Patricia Westlake, Secretary to the Director, for her many courtesies, and to all the other members of the staff who participated in the realization of this exhibition. Considering my normal duties at the City University of New York, the task of guest curator would have been impossible without the devoted secretarial aid of Florence Brill and Melba Warren. Especially, I thank my wife for her support and helpful advice.

Finally, I want to thank IBM Corporation whose financial support made the exhibition possible.

Jacob Lawrence

"The place of Jacob Lawrence among younger painters is unique. Having thus far miraculously escaped the imprint of academic ideas and current vogues in art, to which young artists are most susceptible, he has followed a course of development dictated entirely by his own inner motivations.

"Any evaluation of his work to date is most difficult, a comparison impossible. Working in the very limited medium of flat tempera he achieved a richness and brilliance of color harmonies both remarkable and exciting.

"He is particularly sensitive to the life about him; the joy, the suffering, the weakness, the strength of the people he sees every day. This for the most part forms the subject matter of his interesting compositions.

"Still a very young painter, Lawrence symbolizes more than any one I know, the vitality, the seriousness and promise of a new and socially conscious generation of Negro artists."

This was written by Charles H. Alston, Jacob Lawrence's first teacher, to introduce Lawrence's first one-man exhibition, sponsored by the James Weldon Johnson Literary Guild, at the 135th Street YMCA in 1938. Lawrence was not yet twenty-one, but the comment, after thirty-six years, remains a remarkably perceptive description of his art. Perhaps no other artist of our time has hewn so closely, despite external conditions and personal esthetic evolution, to his original inspiration and principles. There is something monolithic about Jacob Lawrence and his work, a hard core of undeviating seriousness and commitment to both social and Black consciousness. He has projected the Black experience in America more consistently and effectively than any other Black artist of his generation. He has at the same time continued to insist on the larger human struggle for freedom and social justice in all the world and for all people.

Jacob Lawrence is both heir to the "Negro Renaissance" and child of the Depression. When he was brought from Philadelphia to Harlem sometime in 1929 or 1930, he was entering his teens and, also, though hardly aware of it, a new world of intellectual and cultural ferment. In fact, he was part of that mass migration of Blacks from the South (which he was later to recreate in the *Migration* series) that helped spark the Negro Renaissance, as well as Black Nationalism. Black consciousness reached a new level during the Roaring Twenties. In the words of the late James A. Porter, the distinguished art-historian, "Then, for the first time in history, was world attention focused on the cultural heritage and the living arts of the American Negro." The white world had suddenly discovered the Negro; and Harlem, its cabarets, dance halls, theaters, cafes and bars, became an exotic mecca for society slummers, thrill seekers and tourists, but also for more serious white intellectuals and artists who found a new and vital source of American life that they had not known existed. There was an upsurge of interest in Black music, dance, literature and art. Much of this interest may have been patronizing, a bit naive and certainly romantic. Still, in the process, the "New Negro Movement" was given both support and wider exposure, and Black writers and artists for the first time saw the possibility of cultural mobility, if not immediate equality.

However, the Depression hit Harlem, and the Black community in general, with greater severity than it did the rest of the population, and the euphoria of the Jazz Age was replaced by the immediate realities of economic survival. The golden aura of the Negro Renaissance was dimmed; it was not extinguished. The figures of that era, appearing larger than life-size to the younger generation, still populated the cultural landscape of the '30s—culture leaders like W. E. B. DuBois, James Weldon Johnson, Alain Locke; writers like Countée Cullen, Claude McKay, Langston Hughes, Jean Toomer; artists like Aaron Douglas, Hale Woodruff, Augusta Savage, Archibald Motley. As in the '20s, the Schomburg Collection forums were the center of intellectual life and the arts especially were fostered by the Harmon Foundation grants and exhibitions. But it was Government support of the arts through the WPA Federal Arts Project, beginning in the early '30s, that consolidated the drive of Black artists for recognition and sustenance. There was no color line on the art projects, and for the first time Black artists, as well as white, were given the opportunity to practice their art full-time. They became equal members in a community of artists seeking the same objectives, fighting for what they believed to be the rights of all artists in a civilized society. This interplay, and it occurred in all the arts, had a telling effect on racial relations in the United States. Those artists who were on the projects were formed by the experience. Also, almost overnight, there were now enough Black artists and enough activity to warrant the organization of the Harlem Artists Guild.

In addition to supporting art and artists, the WPA had a major interest in fostering community cultural centers and in teaching the arts. The Harlem Community Art Center and the Harlem Art Workshop employed artists like Augusta Savage, Gwendolyn Bennett, Charles Alston and Henry Bannarn as supervisors and teachers, and here a younger generation of Black artists—Norman Lewis, Romare Bearden, Robert Joseph, Ernest Crichlow, Jacob Lawrence—were introduced to art. The generations also found a common meeting ground at 306 West 141st Street, the studio building shared by Charles Alston and Henry Bannarn. Although still isolated in Harlem, the community of Black artists had achieved some identity and was ready to move outward. It was in this ambience that Jacob Lawrence began his career.

Jacob's mother, like so many Black working women, enrolled the children in a day-care center to keep them off the streets; and after school hours Jacob went to Utopia House where he found his recreation in arts-and-crafts activities. He colored with crayons, painted in poster colors, made masks and constructed stage-set models for imaginary plays. There was no formal instruction, only a benign supervision. Charles Alston, just out of Columbia College and newly hired as a recreational instructor, seems to have recognized Jacob's unique personality and talents and to have encouraged his activities without interfering with his natural inclinations or youthful imagination.

Lawrence later attended art classes at the 135th Street Public Library where Alston began teaching under a Carnegie Foundation College Art grant in 1932, and continued with him and Henry Bannarn at the Harlem Art Workshop set up under the WPA in 1934. Meanwhile, Lawrence attended public school and completed two years at the High School of Commerce. He also worked at odd jobs, in a laundry, a bakery, a print shop, and delivering newspapers. He remembers, though not precisely, that when he was about seventeen, he served some six months in a Civilian Conservation Corps camp building a dam near Middletown in upstate New York. Then, in 1937, he received a scholarship to the American Artists School where he studied for about two years with Anton Refregier, Sol Wilson and Eugene Moreley.

It is certainly of more than passing interest that his work shows no influence from any of his teachers. He has said that he was inspired by Brueghel; Käthe Kollwitz; the Mexican muralists Diego Rivera and, especially, Clemente Orozco, who then loomed so large in the American art world; and, surprisingly, Arthur Dove. When he first exhibited in 1938, it was clear that Lawrence was no "primitive"; he had as much training as one would expect a young man of that age to have, and yet his art appeared pure, naive, original, uncontaminated by the mannerisms of the time, except that as a social art it was precisely of its time. His was a new voice with its own pitch and a distinct Black resonance. His subject was Harlem, which he saw freshly not only with an observant reporter's eye, but also as a native son, with empathy and a mordant folk wit. He recorded the demeaning details of slum life, as well as the raucous vitality of the Harlem streets.

Before he exhibited for the first time, Lawrence had already begun work, in 1937, on *Toussaint L'Ouverture*, the

first of the series that are the most characteristic feature of his oeuvre. The notion of a series rather than a single painting to express an idea has historic antecedents from Egyptian wall painting through the mural cycles of the Middle Ages and the Renaissance. That tradition was given a new contemporary relevance by the Mexican muralists and the mural activities of WPA artists of the '30s. One might also adduce the Biblical print cycles of Dürer or the engraved "novels" of Hogarth, but the closest analogy would seem to be the Ben Shahn series of the early '30s: the *Haggadah* illustrations and the *Dreyfus Case* watercolors of 1931 (both, incidentally, inspired by Shahn's concern with "Jewishness" as Lawrence's *Toussaint* was by "Blackness"), the *Sacco and Vanzetti* gouaches (1931-32), the *Tom Mooney* gouaches (1932-33) and the *Prohibition* temperas (1933-34). The concept of individual easel paintings in a coherent sequence is unusual. Lawrence may have seen and been influenced by this format, but certainly not the style.

From the beginning Lawrence felt the single picture, the single impression, the single emotion inadequate to express the multiplicity of his feelings and ideas or to encompass the epic of great historic events. The *Toussaint* series was followed by the *Frederick Douglass* (1938-39) and the *Harriet Tubman* (1939-40). All three sets were bought by the Harmon Foundation, which exhibited them periodically. When the Foundation was dissolved in 1967, Fisk University received the *Toussaint* series, but the other two disappeared from sight. In the course of assembling this exhibition, they have come to light at the Hampton Institute; and for the first time in many years, the *Frederick Douglass* series in its entirety and a selection from the *Tubman* series will be seen again.

Together with the later *Migration, John Brown* and *Harlem* series, they present a remarkable panorama of Black life and history, a body of material that had been systematically excluded from the American experience. Having felt the need to rediscover the heritage of his people and present it to the world in visual terms, Lawrence doggedly set about researching the facts in the resources of the Schomburg Collection. He took notes diligently and created his own scenarios. The scripts are laconically factual with a primer-like simplicity, as if written for Black school children, though the selection of quotations for the *Tubman* series is quite sophisticated, apt and often poetically moving. The caption for each painting is

not, strictly speaking, a title, but a text for which the picture is a visual equivalent or symbol, rather than a literal illustration. The paintings were intended to be seen as a series along with the text, and were so exhibited.

In *Toussaint L'Ouverture* (1937-38), Lawrence recounted the heroic story of the first Black liberation movement that occurred in Haiti during the late eighteenth and early nineteenth centuries. It is also symbolically a statement about Black history in the New World from slavery to liberation, extending temporally and spatially for the American Black the scope of his heritage. The series was exhibited soon after completion at the opening of the De Porres Interracial Center in Harlem in 1939, then at the Baltimore Museum and the following year at Columbia University and the Chicago Negro Exposition, where it was acclaimed for its contribution to Black culture.

Meanwhile, late in 1938, soon after he reached the age of twenty-one and became eligible, Augusta Savage helped him join the WPA Federal Arts Project and he stayed with the easel section for about eighteen months—until its dissolution. He was already involved in the *Frederick Douglass* cycle (1938-39), which was followed by the *Harriet Tubman* (1939-40). (Lawrence has always worked a kind of "academic" year, beginning projects in the fall, completing them by the next spring and breaking off to do something else in the summer.) In the *Douglass* and *Tubman,* Lawrence selected two of the mythic heroes of the struggle against slavery in the United States. The emphasis is on the natural endowment, will to achievement and personal courage of the hero as a symbol of racial pride, but goes beyond to extol education, organization and cooperation with all progressive elements of society, including whites. John Brown appears in both cycles and, in the *John Brown* series (1941-42), he was added to the pantheon of Black liberation. For Lawrence, the Abolition movement was part of a general struggle for universal freedom, social justice and human dignity, and he tells his epic in human terms, factually and almost without prejudice, recognizing the good and bad where it occurs. Thus, Blacks can be heroic, misled or degraded; and whites, altruistic, ignorant or vicious.

In 1940 Lawrence received the first of three Rosenwald Fund Fellowships and began work on the *Migration* series, an account of the massive movement of Blacks from the rural

South to Northern urban centers during and after World War I, a historic occurrence of profound significance not only for the Black people, but for America in general. A sociological rather than a heroic epic, it is not the story of individuals or specific events, but of anonymous humanity. And the paintings manage to capture in an uncanny way the rhythm of a people in flux, the vulnerability of huddled masses, the force of history driving people like scraps in a wind.

Lawrence was still not very well known beyond the Harlem community. The *Douglass* and *Tubman* series had not been widely shown. In general Black artists had little exposure below 110th Street, and none had permanent galleries. However, the cumulative effect of progressive propaganda for racial equality and the common experience of artists on the projects became noticeable. Edith Halpert at the Downtown Gallery was anxious to foster Black art and find a negotiable artist for her own stable. In the fall of 1941 she conceived of an all-Black show which might introduce Black artists to the art dealers. Lawrence was sent to her by Dr. Alain L. Locke, and she decided immediately to give him a one-man show. At the same time, Charles Alston, with a commission to illustrate an article for *Fortune* magazine on the integration of Blacks into the growing war effort, showed the *Migration* series to the art editor who was greatly impressed and decided to reproduce twenty-six of the sixty panels as a portfolio for that issue, which incidentally also had a cover by Romare Bearden. Lawrence had married a fellow painter that summer, the West Indian-born Gwendolyn Knight, whom he had met at the Harlem Workshop, and they were in New Orleans when the opening of the show at the Downtown Gallery and the attack on Pearl Harbor occurred simultaneously. First responses were muted by the national crisis, but it was soon evident that, abetted by the *Fortune* portfolio, the exhibition was a smash, a new young artistic star had emerged, and America had *a* Black artist. Lawrence's success was deserved. The volume of production, originality, emotional power, social relevance, artistic quality all indicated an unusual and welcome talent. Here was a Black artist dealing seriously and boldly with Black life, breaking through racial stereotypes and hackneyed artistic mannerisms, expressing himself in a contemporary idiom. But is it also true that the apparent primitivism, the childlike directness, the vibrant color conformed to a preconceived image of what Black art should be like?

Overnight success had little effect on Lawrence, who remained in New Orleans working on the *John Brown* series he had already begun. On the way home in early 1942, the Lawrences spent several months among family in Lenexa, Virginia. It was the first time he had been in the rural South, the land his parents had come from, and the few paintings he did then have another flavor, moody, dark and nostalgic. Back in New York, Lawrence began a new series and, departing from the format of the earlier historic cycles, he turned to the documentation of contemporary life in Harlem. The *Harlem* series, based on his own experience, is more immediate, full of observed incidents, rich in genre detail, pulsating with life and movement. There is also a new note of personal involvement. The vignettes of life in the streets, the teeming slums, the cafes, poolrooms and bars, the churches and schools, are seen objectively, but with sympathy, humor and critical acuity. In moving from history painting into the mainstream of social realism, Lawrence had recaptured the native flavor of the Ash Can tradition, though in a new ethnic guise.

The six cycles—*Toussaint, Douglass, Tubman, Migration, John Brown* and *Harlem*—the major output of Lawrence's early maturity, constitute an imposing body of work and form in general a coherent stylistic unit. They have in common a naive simplicity of conception, a directness of statement and an uninhibited emotionalism. Lawrence as a young artist, learning his métier, was developing from tentative gropings to an increasing control of his artistic resources. The primitivism was his style, his natural form of expression. From the outset, the style seemed intuitively at one with the content. He avoided the appearance of sophistication, though his use of "expressionist" distortion would indicate an awareness of modern art forms. Except for the *Harlem* series, the other five cycles taken as a whole are a notable feat of imaginative recreation of the past and unknown places, a projection of visual imagery that might have grown out of those earlier practices of childhood fantasy. The events are evoked in forthright but intense dramatic compositions, guilelessly obvious, yet often unexpectedly daring. Similarly, the compelling rhythms of the simple narrative are interrupted by harshly angular gestures and explosive movements. Form is seen in color areas, color as rudimentary and uninflected, yet the result is not flat decorative pattern. On the contrary, there is a strong feeling for space and the illusion of depth and movement are created by color juxta-

position, exaggerated perspective and unusual angles of vision. At first sight Lawrence's color may seem simplistic; in the *Douglass* series, for instance, he uses a very limited palette of the primaries, red, yellow and blue, with the addition of green, brown and beige, and black and white, all without mixture. In all his early work he held to the pure primary and secondary colors, and yet the paintings are never gay or coloristic. They have instead an astringent quality, a harsh and sometimes awkward dissonance. There is little in his work that is pretty and his lyricism is sadly haunting. In the paintings of this period, Lawrence has little recourse to line though his style is essentially linear in its sharp definition of edges. He has never thought of drawing as an independent medium and has rarely done sketches for their own sake. For him drawing is a preparation for painting, evolves in the process and is obliterated in its consummation. Yet drawing in the larger sense is a fundamental ingredient in his style, the prime carrier of emotion. Crude, sometimes halting, even childlike and violently, almost hysterically distorted, his drawing is capable of plumbing the nature of the personae of his paintings, driven by inner tensions or outer forces, of revealing formally the fanaticism of John Brown or the fervor of Harriet Tubman.

The six sets are far from homogeneous. Each, done as a unit in a short span of time, has its own character. Done together, they are expected to be seen together (the *Migration* series is split between The Museum of Modern Art and The Phillips Collection, and, except for the *Harlem* series which is scattered, the others are intact). Each has a unifying mode or rhythm, a repetition of motifs and forms, a common palette and medium and a standard size. The *Harlem* series is unique in its genre content. On the other hand, the *Tubman* set is unique technically. The tempera is applied thinly on a gesso ground, creating the appearance of fresco. The ground, visible through the transparent pigment, serves to lighten the hue and reveal the brushwork in the modeling of form. The milky color and rather feverish drawing makes it the least appealing of the series, but it includes some of his most imaginative concepts. On the whole, the developmental line of his art in those years, though not undeviating, moves from the narrative to the symbolic, from the intuitive and immediate to the more deliberate and self-consciously formal. His art was, however, still in charmed balance between spontaneity and control,

between the naive and the profound.

During these years, Lawrence painted individual pictures outside the historical series that are neither politically nor ideologically motivated; they continue his earlier interest in contemporary Black life and fall within the orbit of the *Harlem* series. As a matter of fact, until fairly recently, Lawrence has periodically returned to this theme, as if to reestablish ties with his origins.

Along with many other Americans, Jacob Lawrence's life and career were interrupted by World War II. In October 1943 he was inducted into the United States Coast Guard as a steward's mate, the usual rating for a Black entering that service at the time. He took his boot training at Curtis Bay, Maryland, and was then transferred to an officers' training station in St. Augustine, Florida. Here, as a successful artist masquerading as a servant, he felt for the first time the full force of racial discrimination. But Lawrence was once again fortunate that his commanding officer, Captain J. S. Rosenthal, was aware of the situation, encouraged him to continue painting, even offering him the refuge of his quarters, and was finally influential in having him assigned to the first "integrated" ship in the service, the weather patrol boat *USS Sea Cloud,* the transformed yacht of Joseph E. Davies, former United States Ambassador to the Soviet Union. Of his service on the *Sea Cloud,* Lawrence has said that it was "the best democracy I've ever known." The captain of the vessel, Lieutenant Commander Carlton Skinner was helpful in getting Lawrence a rating as a public relations Petty Officer, 3rd Class, so that he could devote himself to painting. He subsequently served on the troop carrier *USS Gen. Richardson,* visiting many foreign ports in the course of duty. During his Coast Guard service, Lawrence painted a series of pictures, some of which were exhibited in 1944 at The Museum of Modern Art. The Coast Guard has records of forty-eight such paintings having been in its archives. The last record of them, before their reported dispersal, dates back to 1961. Their whereabouts are now unknown, though the hope is that they still exist at Coast Guard installations throughout the world.

The few identifiable works of this period, signed and dated with the accompanying USCG, do not correspond to any of those described in the only extant list. From the evidence of these paintings, which may have been done apart from his official duties, and the photographs of those exhibited in 1944,

it is clear that Lawrence's art was undergoing a major transformation. Removed from his normal environment and patterns of work, he was forced to deal with a new range of subjects and in a different context. The result was a more concentrated observation of incident and a more formal and sophisticated handling of the single work. The composition became tighter, the detail much more elaborate and controlled. A new awareness of the frame is obvious and the paintings begin to look more like "works of art."

Discharged from the service in December 1945, Lawrence returned to life as a successful artist. The *John Brown* series was exhibited for the first time at the Downtown Gallery, then at the Boston Institute of Modern Art, and circulated nationally by the American Federation of Arts. The first works done after his return to civilian life imply a need to find his moorings. They deal with homecoming, with revisiting scenes of the past, but also with an entirely new theme—people at various occupational tasks, interpretable as a symbolic reference to work and rebuilding. They are infused with calmness and ideality and expressed in a new "classic" composition and subdued color. When he accepted an invitation to teach at Black Mountain College in the summer of 1946, he met and was greatly impressed by Josef Albers, whose conceptions of formal structure reinforced his own already emerging tendencies toward abstraction.

A Guggenheim Fellowship in 1946 permitted Lawrence to undertake a new series recapitulating his war experiences. The fourteen paintings of the *War* series continue the manner begun in the *Coast Guard* paintings, but in a departure from his earlier cycles, this series has no unifying text. The individual pictures are self-contained expressions of an idea or an impression, and have titles. Thus *War* is not really a series in the older sense, but a cycle of paintings related to a single theme, and it was a format that he would favor from this time on. It is also not a programmatic treatment of war, either historically or ideologically, but a collection of images, some of which are the distillation of personal observations in the Coast Guard, and others the symbolic expression of more general experience. The former are, on the whole, more successful. The *War* series heralds an esthetic as well as a thematic change. Focus on the single frame creates a chain reaction, the subject becomes isolated, the action synthesized, the detail subordinated. The result is a much more intricate, intellectualized

and artistically sophisticated formal structure. For the first time in Lawrence's work, one is uncomfortable with the scale. Someone should have given Jacob Lawrence a wall, for many of these paintings look like mural studies and they call for more monumental treatment.

A commission from *Fortune* in 1947 to do a series of ten paintings on the postwar South brought Lawrence back to the current and the incidental, and the paintings he did in the next two years are concerned with Black life in the South and the North. They have that same quality of insatiable interest in human activity that characterized his earlier work. He even recaptures some of the former looseness and vitality; but life is now seen by a more critical eye and rendered by a more sophisticated hand. There is a new sharpness in his observation, a new asperity in his criticism, an unexpected irony in his humor. The efforts at idealization, at optimism, at positive thinking fall flat. The boozers and gamblers are more convincing, even more human, than the shoemakers or businessmen.

In 1949, in the midst of increasing recognition, prizes and honors, Lawrence experienced a psychological crisis which led him to enter Hillside Hospital, a mental institution in Queens, for psychiatric treatment. He spent nine months there and emerged readjusted adequately enough to continue functioning as a person and an artist. The paintings he did during his stay may have played some part in his rehabilitation, but they also serve as a penetrating insight into the circumstances of mental illness and therapy. The eleven scenes of patient activities and hospital routine manage to convey a sense of institutional life and the particular states it induces—boredom, depression, panic. They are pervaded by an air of hysteria compounded of pointlessness and urgency. It is a sick world and, for the first time in Lawrence's art, a totally white one. These pictures are a complete departure from the concentrated emotional expression and narrative directness of his previous work. They are, on the contrary, unstable, diffuse, deeply introspective, full of despair and aimless frenzy. Artistically, the formal stability of an earlier time gives way to a fragmentation that is held in precarious balance only by the act of creation. Certainties of space, form and color disappear in a kaleidoscope of shifting images. There is an excessive concern with detail and with intricacy itself, a nervous surface agitation. The color turns light and acidulous, and line, tortured

and involuted, becomes the major vehicle of expression. They are remarkable and moving evocations of mental illness.

In the early '50s Lawrence reworked these new elements into a coherent style in which the splintering fragments of color and form are tightened into an intricate containing web. Space and mass dissolve in a veil of sparkling facets. The *Performance* theme which dominates the work of this period lends itself naturally, in its preoccupation with both creative introspection and theatrical illusion, to Lawrence's art which was then involved with both psychological probing and esthetic prestidigitation. It could have been the tenor of the time, the cold war and the decline of social realism, that led Lawrence further into himself and an increasing concern for esthetic values in themselves, and to the magic in the manipulation of form. The works of this period are extremely intricate, carefully crafted, skirting the edge of abstraction, creating a world that hovers in more than one sense between illusion and reality.

Lawrence must have been aware of the direction his work was taking and have felt the need for a return to simplicity and to social comment, to a reaffirmation of his own deepest beliefs. At the height of the McCarthy era, he returned, in the *Struggle* series (1955-56), to the revolutionary history of the American people. And he also returned to the sources of his art, to the Mexican muralists and social realism. The influence of Orozco is strongly felt in the dynamic surge of forms and sharp contrasts of light and dark. The compositions are monumental and classic in conformity with the heroic and symbolic content. But they have also become more elaborate, form and color more orchestrated, the decorative quality more pronounced. There is no vestige of naiveté in these works, though Lawrence did recapture some of the directness and passion of his youth.

In the mid-'50s Lawrence began to teach regularly at Pratt Institute, where he remained for fifteen years, and intermittently at various other art schools and college art departments, and his art took on a more academic and even placid character. Lawrence was shaken out of this routine art activity by the explosive civil rights struggles in the South, and in 1962 he began a series of what are essentially polemical paintings on that theme. They are full of anger and satirical bite, indictments of racial injustice, bigotry and human stupidity. But the heat of indignation and the powerful impact of some of the paintings can not hide the fact that his style had become more formal and decorative.

The growth of Black nationalism in the United States brought with it an increased consciousness of and interest in Africa and Black Africans, and, in spite of a lifelong stance against cultural Black nationalism, Lawrence found the trip with his wife to Nigeria in 1964 rewarding and refreshing. Regardless of political conviction, a trip to Africa for any Black American must be a homecoming and a liberation. The *Nigeria* sequence is full of a new freedom and joy, lively, panoramic and colorful in a new decorative sense. Many of these qualities were carried over into the paintings he did as illustrations for *Harriet and the Promised Land* (1967), a children's book on the life of Harriet Tubman. There are almost thirty years between the two "Harriet" series and their intentions were quite different, but it is fascinating to observe the quite obvious differences and the more subtle similarities.

Lawrence was appointed Full Professor at the University of Washington in 1971, and he and his wife now live in Seattle. It is a "retreat," not in the sense of defeat, but renewal. As he himself would say, "Nothing is ever permanent, and I may come back." He has in these years moved out of the eye of the storm and perhaps deeper into himself. His work has taken on a more philosophic air, as if he were searching for some symbolic significance in life. He has turned to re-examining older themes, though it should be said that he has done so throughout his career, but especially those of the library and the builder. Is he saying that the future of the Black lies in education and constructive, creative labor, and along with whites, for in the *Builder* pictures Black and white work together? This is what Lawrence has always believed.

Jacob Lawrence was the first Black artist to be accepted so completely by what was essentially a white art world. He was also the first wholly authentic voice of the Black experience in the plastic arts. He has carried the honor and the burden well. It has not been easy to live as a token Black in a white cultural world, nor to suffer the inference of "Tomism" from his fellows. From the beginning, his art was not only about Blacks, but represented them honestly without idealization, sentimentality or caricature. At the same time, as a social realist, he considered the struggle of his people as part of a larger "struggle of man always to better his conditions and to move forward . . . in a social sense."* Times have changed and the "integrationist" stance has come under attack from younger

militant Black artists. He admits readily that his acceptance was unique, that there are color bars in art as in life, that Blacks in America are unfairly treated, even oppressed and exploited, but he also insists that he was helped by whites as well as Blacks, was recognized by whites and has been successful in a white world. No one can question his credentials as a "Black" artist and he is proud of his achievement, but like many of his fellow Black artists, he would rather be accepted just as an artist. It is not only Lawrence's racial posture that has come under attack. For a large part of his creative life, since the end of World War II, social art has been out of favor, and though he may continue to sell, exhibit and receive honors, he gets little critical attention in an art world dominated by other values. Still, he continues to survive and create. In an interview, Lawrence was asked by Carroll Greene how he managed to maintain his identity in an art world so hostile to his beliefs. Lawrence answered, "I have an assuredness of myself."*

Milton W. Brown
Graduate School
City University of New York

* Quotations from Carroll Greene, *Interview with Jacob Lawrence,* October 25 and November 26, 1969 (Archives of American Art, Smithsonian Institution, New York).

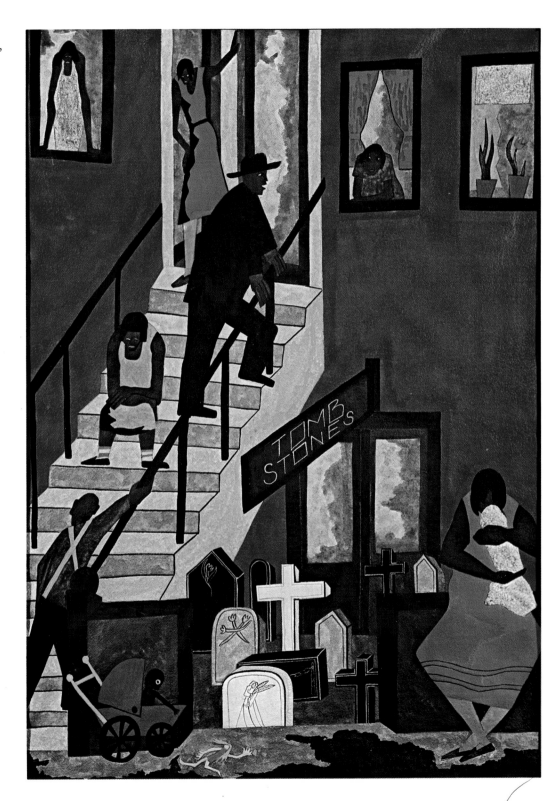

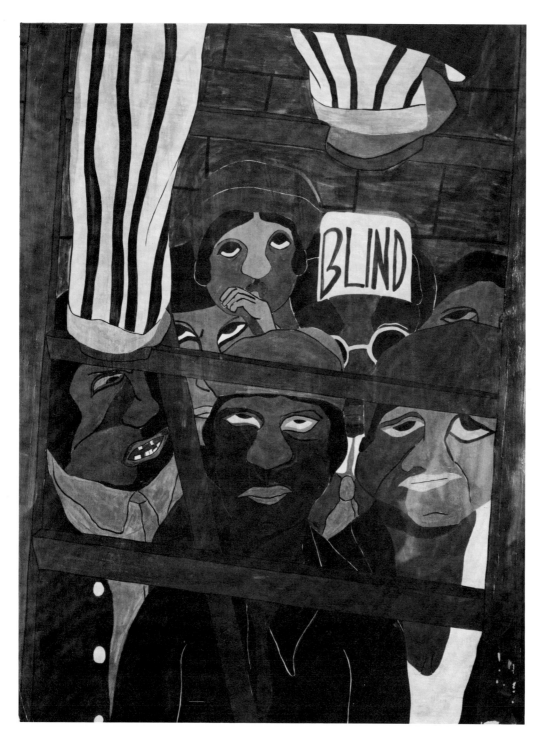

1. *Street Orator*, 1936.
Collection of Mrs. Jacob Lawrence.

3. *Rain*, 1937.
Collection of Mrs. Jacob Lawrence.

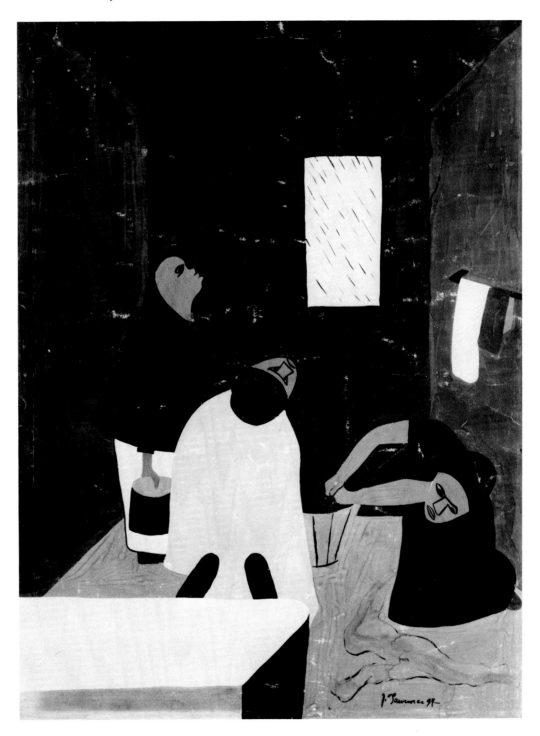

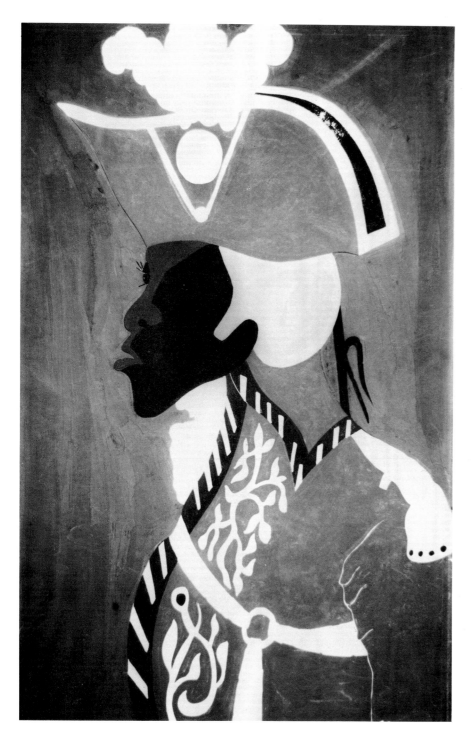

8. *Toussaint L'Ouverture Series, No. 20,* 1937-38.
Department of Art, Fisk University, Nashville, Tennessee.

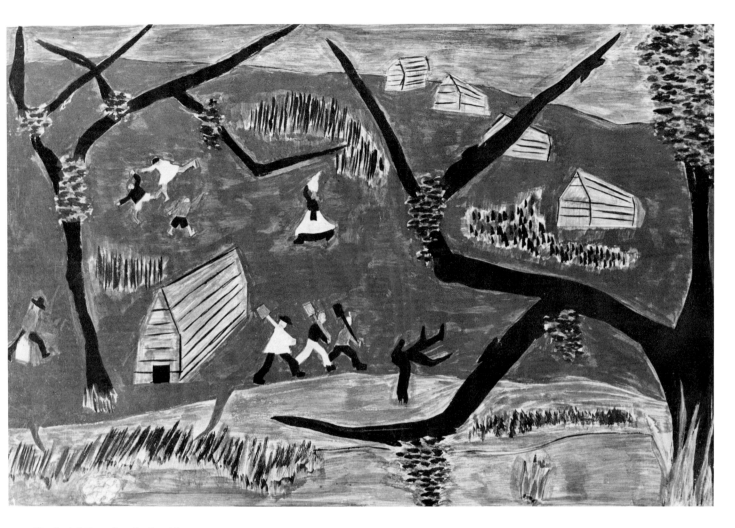

15. *Frederick Douglass Series, No. 1*, 1938-39.
Hampton Institute, Virginia.

52. *Harriet Tubman Series, No. 18*, 1939-40.
Hampton Institute, Virginia.

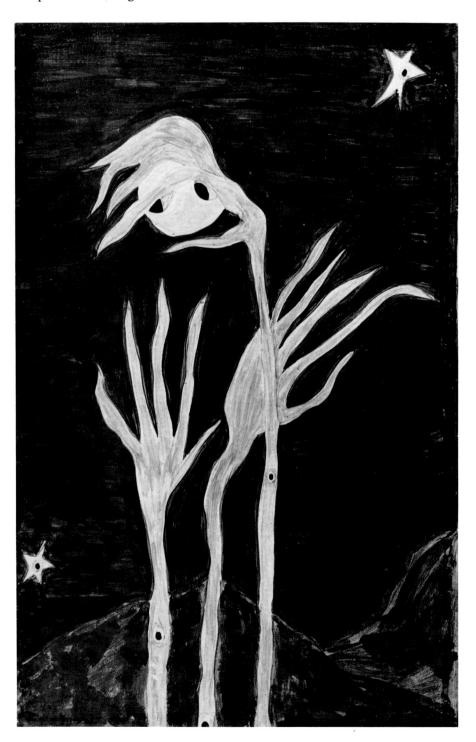

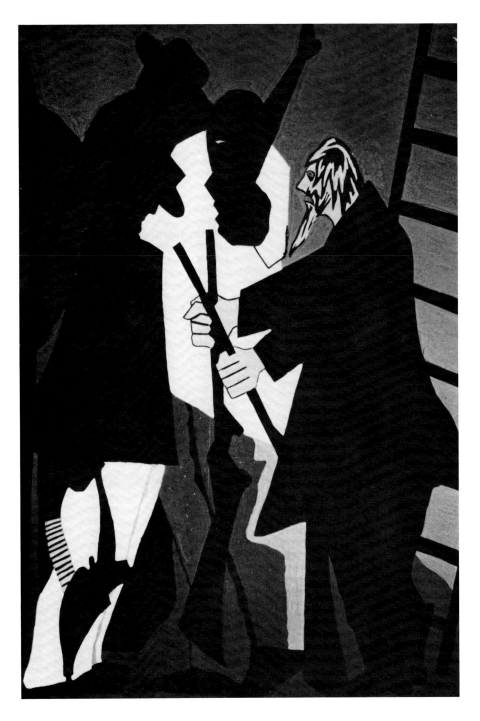

73. *John Brown Series, No. 6*, 1941.
The Detroit Institute of Arts; Gift of Mr. and Mrs. Milton Lowenthal, 1955.

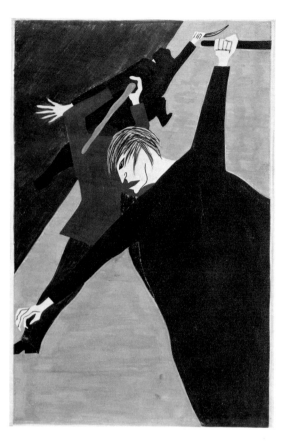

67. *Migration Series, No. 50,* 1940-41.
The Museum of Modern Art, New York; Gift of Mrs. David M. Levy, 1942.

Below
57. *Migration Series, No. 3,* 1940-41.
The Phillips Collection, Washington, D. C.

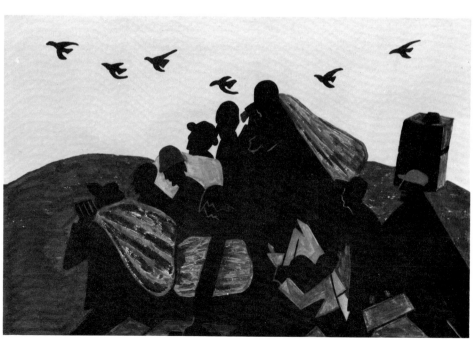

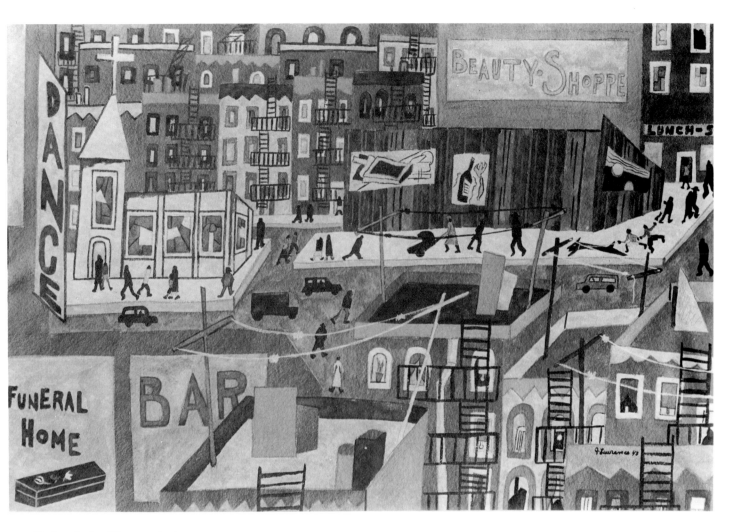

85. *Harlem Series, No. 1,* 1942-43.
The Hirshhorn Museum and Sculpture Garden, Smithsonian Institution, Washington, D. C.

89. *Harlem Series, No. 27*, 1942-43.
New Jersey State Museum, Trenton; Gift of the Friends of the New Jersey State Museum.

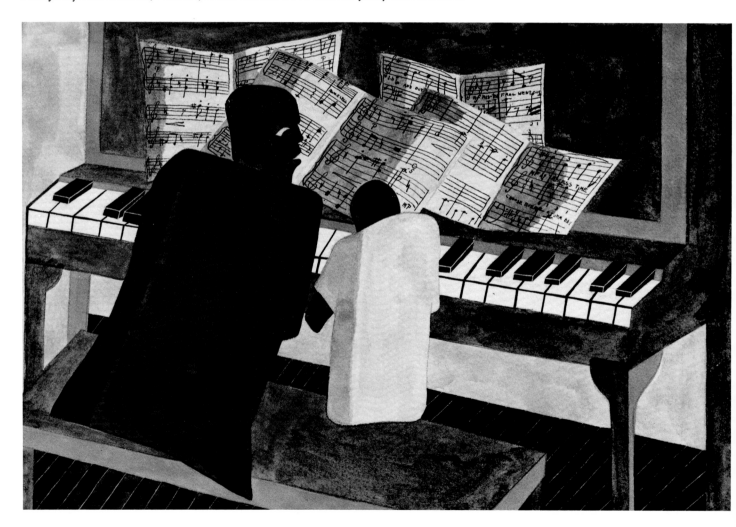

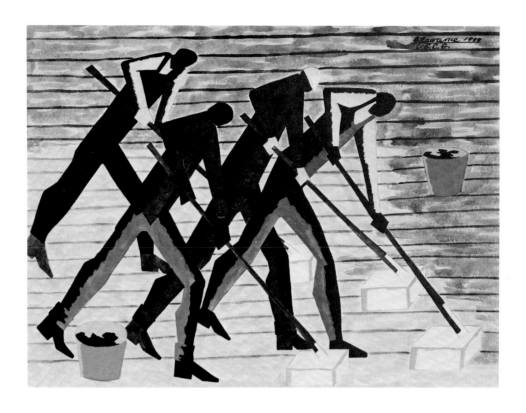

Holystoning the Deck, 1944.
Not in exhibition; whereabouts unknown.

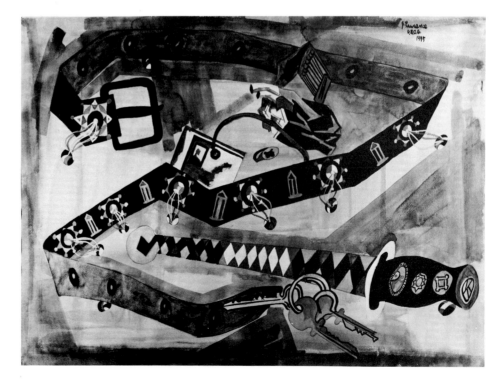

93. *Seaman's Belt,* 1945.
Albright-Knox Art Gallery, Buffalo,
New York; The Martha Jackson
Collection, promised gift

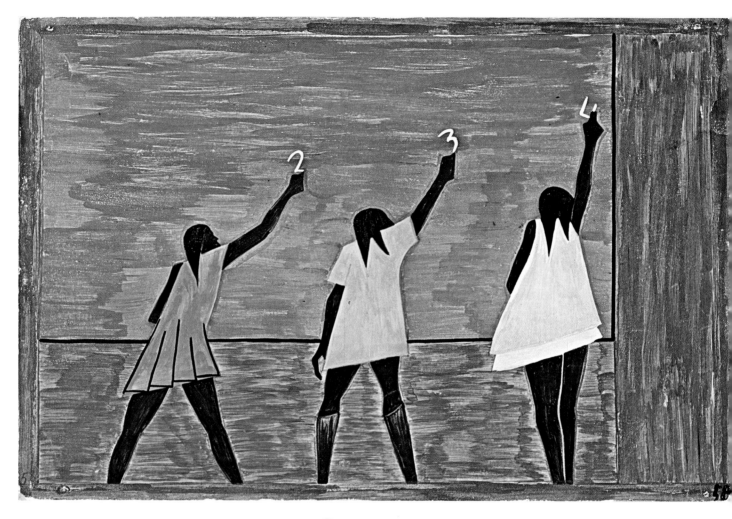

67. *Migration Series, No. 50,* 1940-41.
The Museum of Modern Art, New York; Gift of Mrs. David M. Levy, 1942.

96. *The Lovers*, 1946.
Collection of Mrs. Harpo Marx.

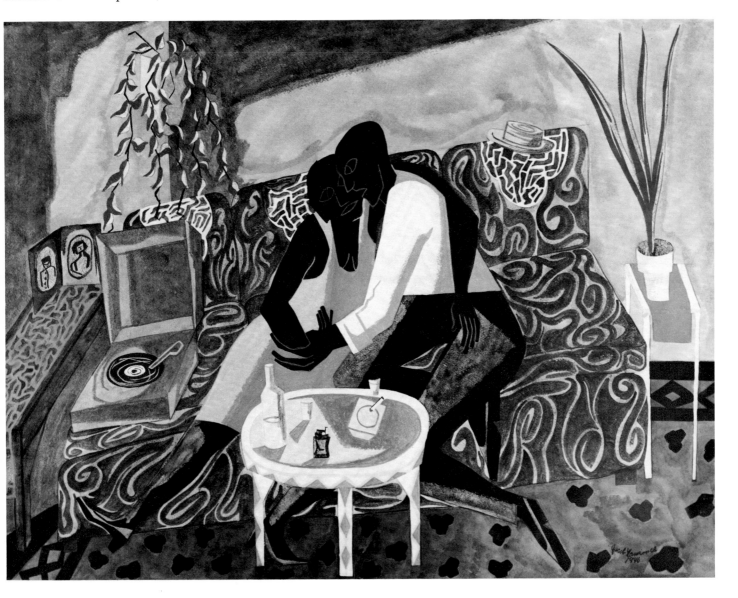

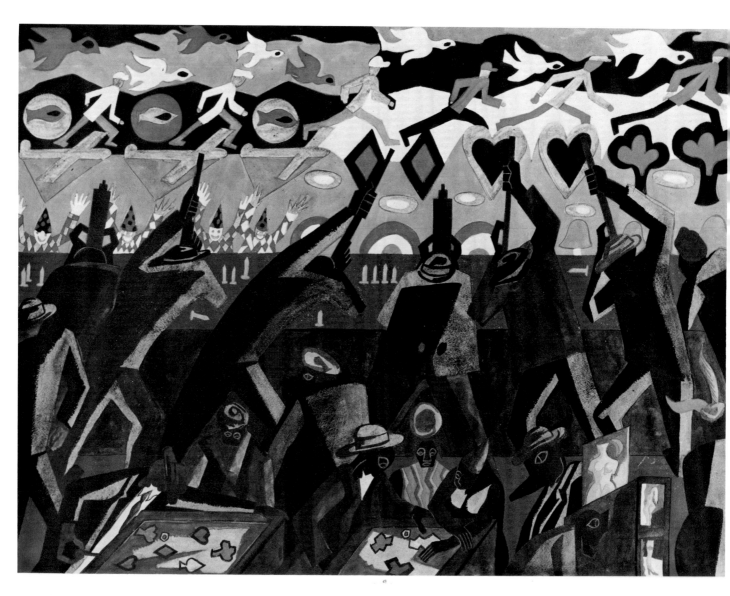

97. *Shooting Gallery,* 1946.
Walker Art Center, Minneapolis;
Gift of Dr. and Mrs. Malcolm McCannel.

108. *War Series, No. 12*, 1947.
Whitney Museum of American Art, New York; Gift of Mr. and Mrs. Roy R. Neuberger.

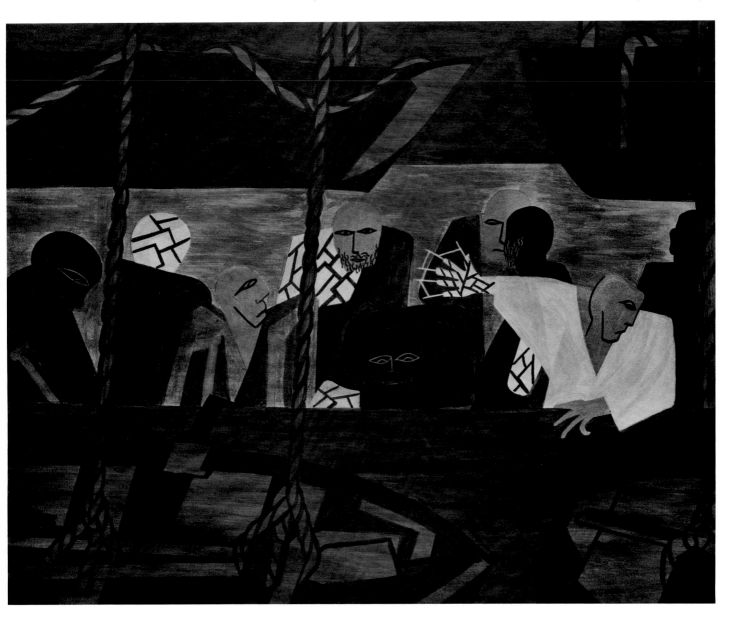

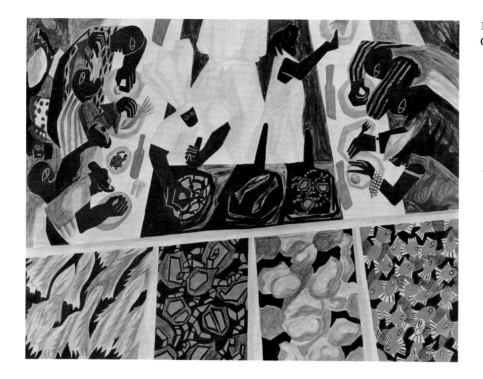

101. *Catfish Row,* 1947.
Collection of Mr. and Mrs. Robert D. Straus.

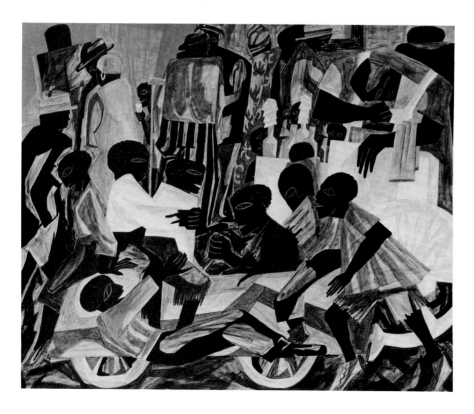

109. *Summer Street Scene,* 1948.
Collection of Alfred E. Jones, Jr.

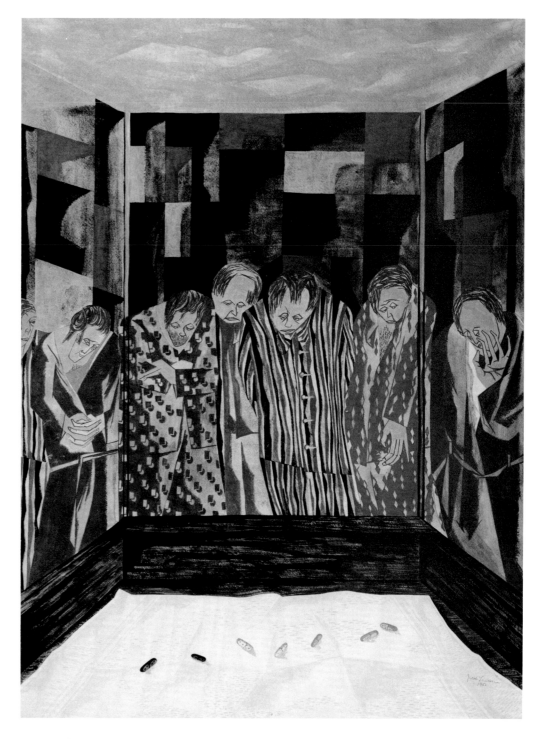

111. *Sedation,* 1950.
The Museum of Modern Art, New York; Gift of Mr. and Mrs. Hugo Kastor.

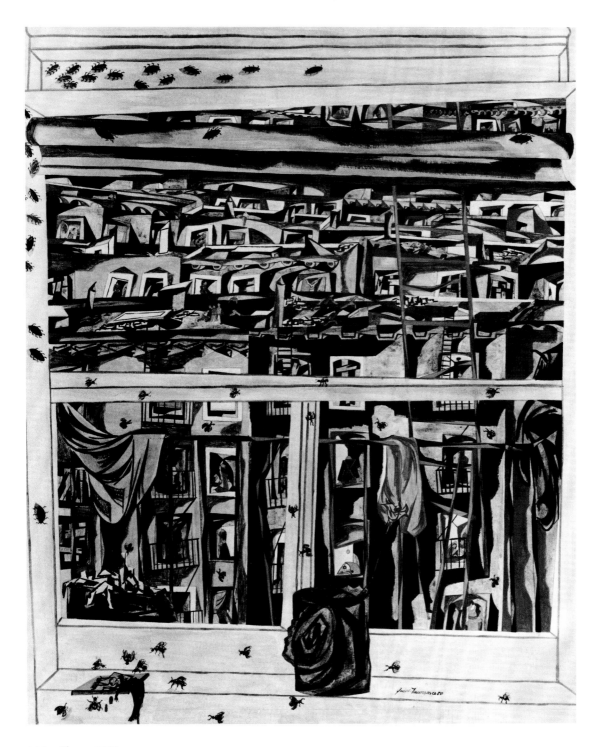

115. *Slums,* 1950.
Collection of Mr. and Mrs. William A. Marsteller.

118. *Vaudeville,* 1952.
The Hirshhorn Museum and Sculpture Garden, Smithsonian Institution, Washington, D.C.

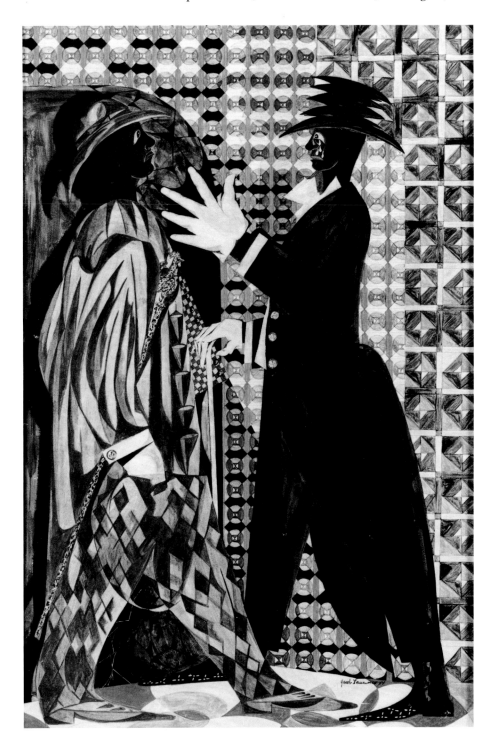

123. *Village Quartet*, 1954.
Collection of Mr. and Mrs. John C. Denman.

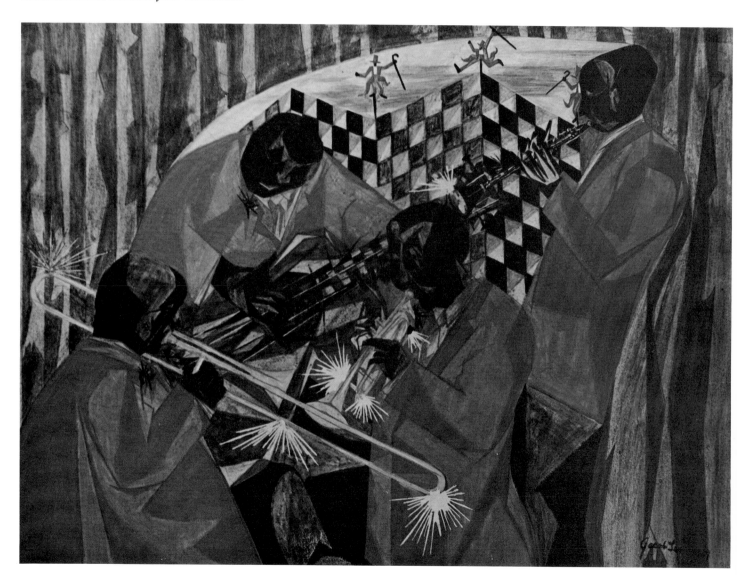

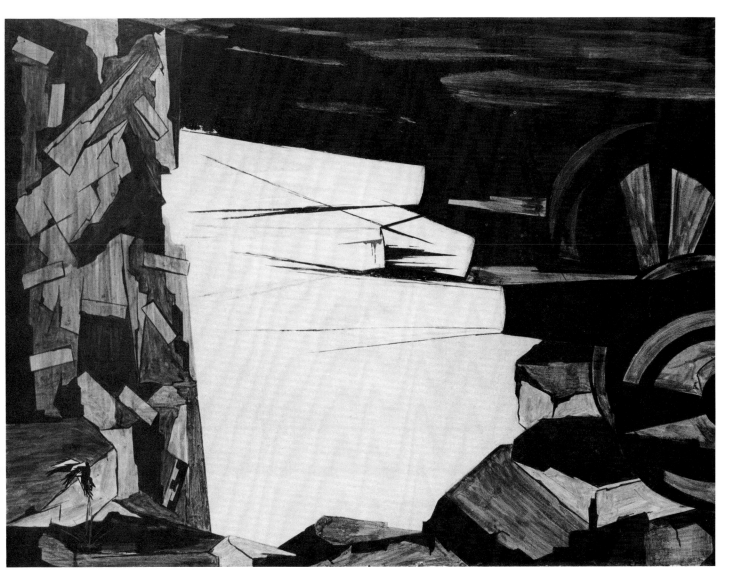

133. *Struggle Series, No. 24*, 1955-56.
Terry Dintenfass, Inc., New York.

121. *Surgery, Harlem Hospital,* 1953.
Collection of Dr. Cyril C. Ollivierre.

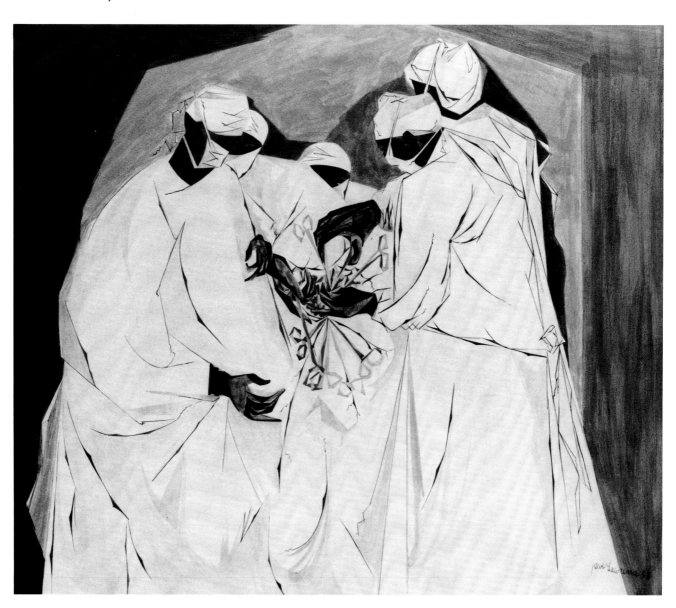

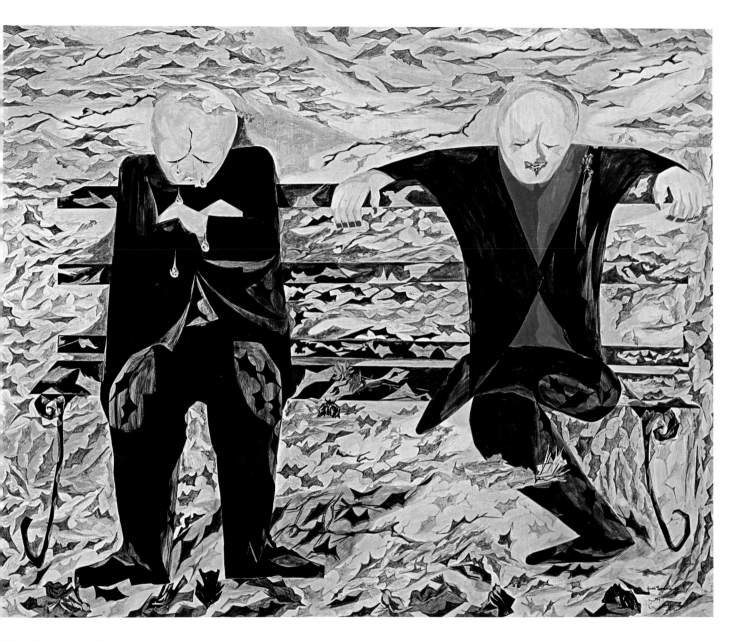

19. *Tragedy and Comedy,* 1952.
Collection of Mr. and Mrs. Alan Brandt.

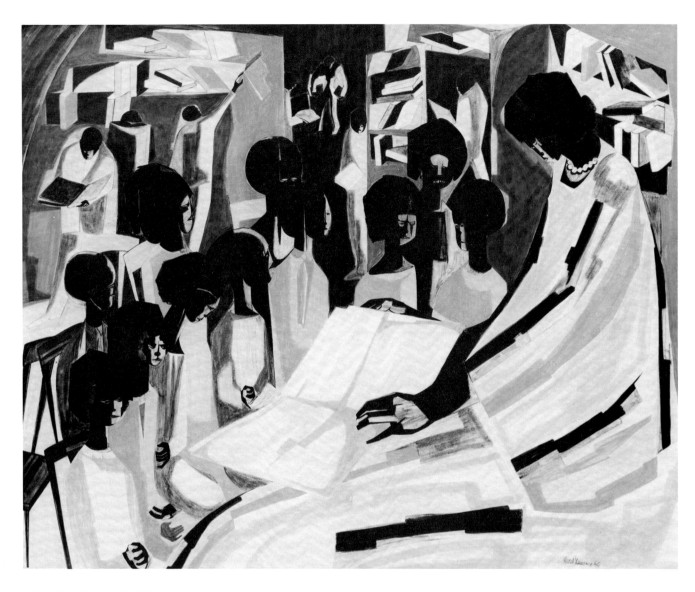

140. *The Library II*, 1960.
Collection of Dr. and Mrs. Martin Cherkasky.

Opposite
142. *The Ordeal of Alice*, 1963.
Collection of Dr. and Mrs. Herbert J. Kayden.

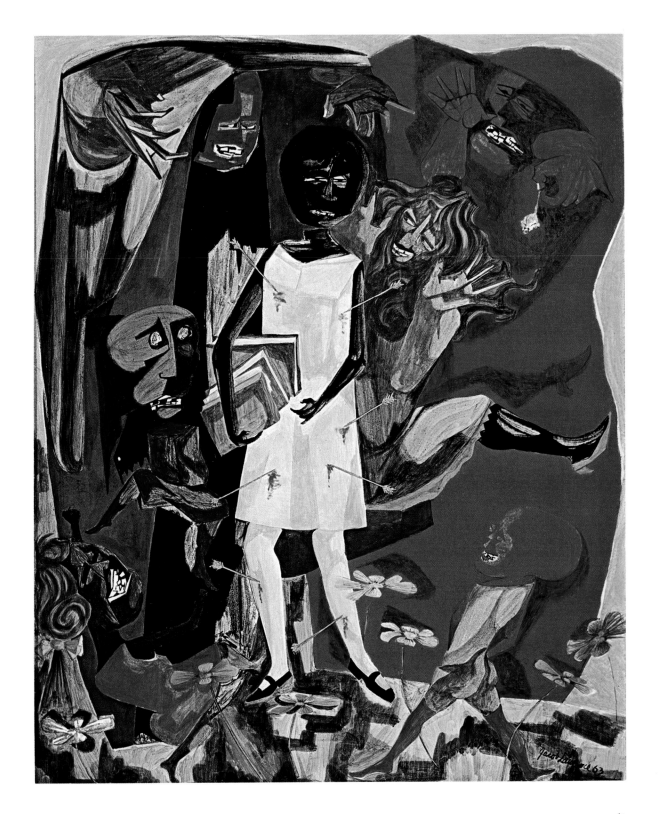

148. *Dreams No. 1*, 1965.
Collection of Ruth and Jack Wexler.

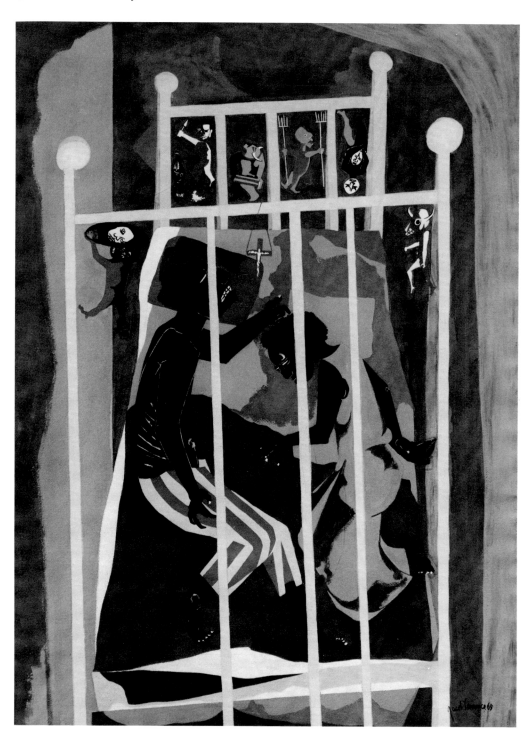

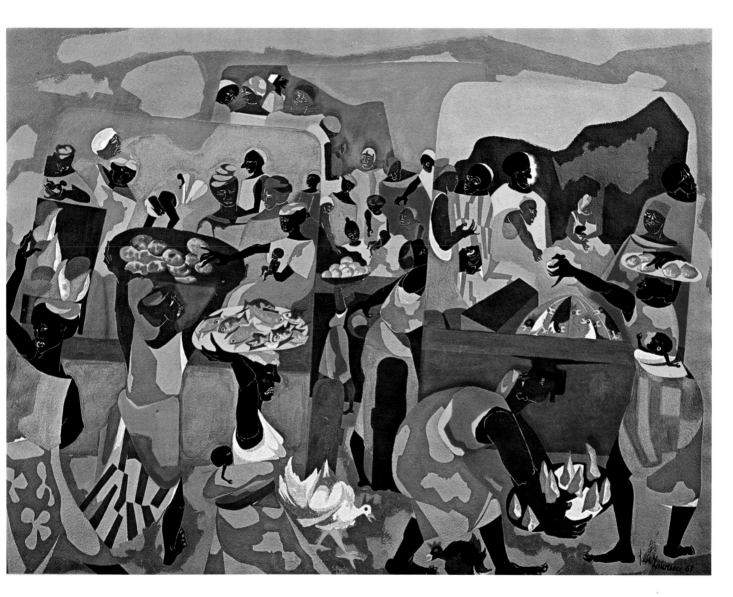

145. *Three Red Hats*, 1964.
Collection Mrs. J. E. Spingarn.

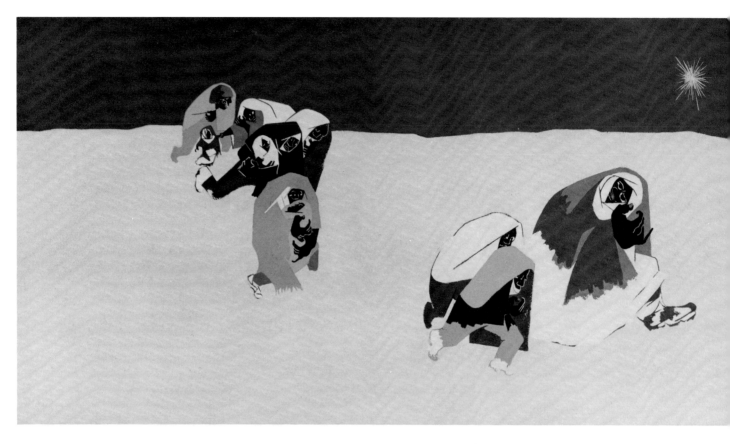

152. *Canada Bound* (Illustration for *Harriet and the Promised Land*), 1967.
Collection of Dr. and Mrs. James L. Curtis.

154. *Builders No. 2*, 1969.
Collection of Mrs. B. J. Ronis.

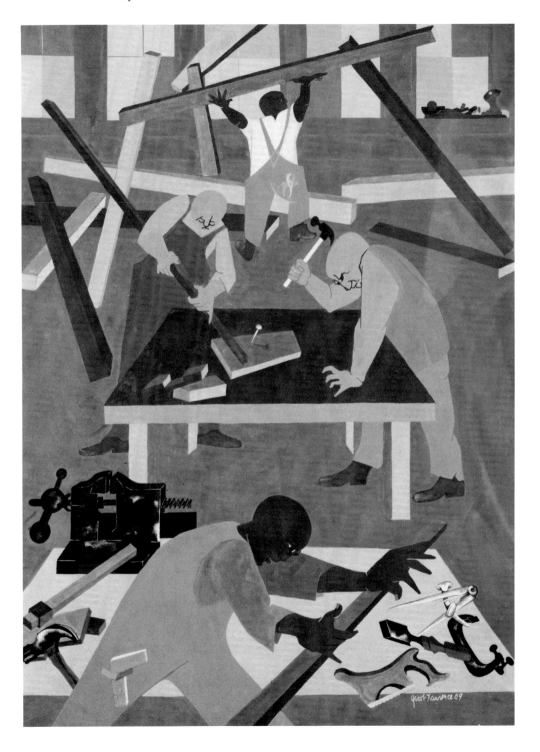

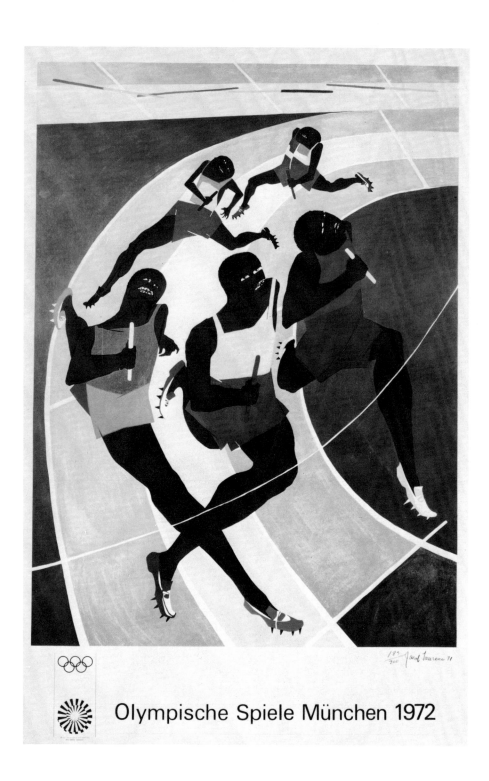

Poster reproduction of *Munich Olympic Games,* 1971 (Catalogue No. 155).

162. *George Washington Bush Series, No. 4*, 1973.
State Capitol Museum, Olympia, Washington.

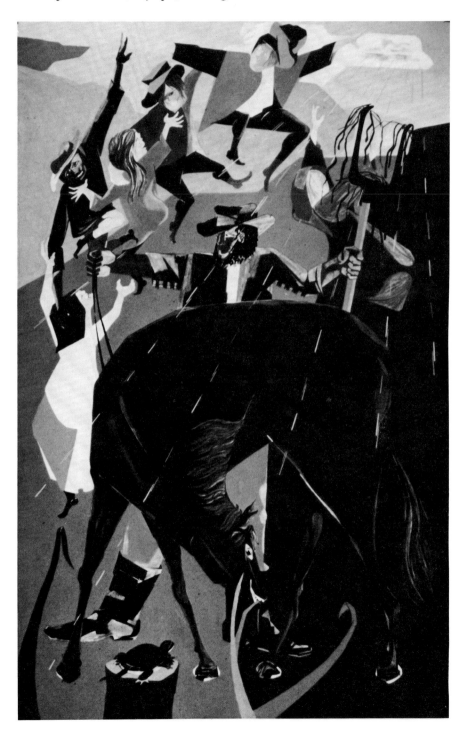

Chronology

1966 Instructor, New School for Social Research, New York (about 3 years).
1967 Instructor, Art Students League, New York (about 2 years). Paintings for *Harriet and the Promised Land.*
1968 Began paintings on *Builder* theme.
1969 Visiting artist, California State College, Hayward (September-March 1970).
1970 Visiting artist, University of Washington, Seattle (April-June).
Appointed Full Professor, Coordinator of the Arts and Assistant to the Dean of the Art School, Pratt Institute.
Illustrations for *Aesop's Fables.*
1971 Appointed Full Professor, University of Washington.
1972 Commissioned to design poster for the 1972 Olympic games.
1973 *George Washington Bush* series.

Awards

1937 Scholarship for two years study at the American Artists School.
1940 Rosenwald Fund Fellowship.
Second Prize. American Negro Exposition, Chicago.
1941 Rosenwald Fund Fellowship Renewal.
1942 Rosenwald Fund Fellowship Renewal.
Sixth Purchase Prize, Artists For Victory Exhibition, The Metropolitan Museum of Art, New York.
1946 John Simon Guggenheim Memorial Fellowship.
1948 Norman Wait Harris Silver Medal and Prize, International Watercolor Exhibition, Art Institute of Chicago.
Certificate of Recognition, *Opportunity* Magazine.
First Prize in Watercolor, Brooklyn Society of Artists.
Purchase Award, Seventh Annual Exhibition of Contemporary Negro Art, Atlanta University.
Honorable Mention, Pennsylvania Academy of Fine Arts.
1952 Honorable Mention, Biennial Exhibition of Brooklyn Artists, The Brooklyn Museum.
1953 Citation and Grant, National Institute of Arts and Letters.
1954 Chapelbrook Foundation Fellowship.
1955 First Prize (shared with Stuart Davis), Mural Competition, United Nations Building (National Council of United States Art).
1965 Elected member, National Institute of Arts and Letters.
1970 Honorary Doctor of Fine Arts, Denison University, Granville, Ohio.
Spingarn Medal, N.A.A.C.P.
1971 Elected Associate, National Academy of Design, New York.
Honorary Doctor of Fine Arts, Pratt Institute, New York.

1973 The Brooklyn Arts, Books for Children Citation for 1973, presented by The Brooklyn Museum and the Brooklyn Public Library.

One-man exhibitions

1938 Harlem Y.M.C.A., New York, sponsored by James Weldon Johnson Literary Guild.
1939 De Porres Interracial Center, New York (*Toussaint L'Ouverture* series).
Baltimore Museum of Art (*Toussaint L'Ouverture* series).
1940 Columbia University, New York (*Toussaint L'Ouverture* series).
1941 Downtown Gallery, New York (*Migration* series).
1943 Downtown Gallery (*Harlem* series).
Portland Art Museum, Oregon.
1944 The Museum of Modern Art, New York (*Coast Guard* paintings and 30 *Migration* series paintings).
1945 Downtown Gallery (*John Brown* series).
Boston Institute of Modern Art (*John Brown* series).
John Brown series circulated by the American Federation of Arts.
1947 Downtown Gallery (*War* series).
New Jersey State Museum, Trenton.
1950 Downtown Gallery (*Hospital* paintings).
1953 Downtown Gallery (*Performance* paintings).
1957 Alan Gallery, New York (*Struggle* series).
1959 Exchange exhibition with Russia, sponsored by the State Department.
1960 Washington Federal Savings and Loan Association of Miami Beach, Florida.
The Brooklyn Museum, sponsored by the Ford Foundation, and circulated by the American Federation of Arts to sixteen United States cities.
1962 M'Bari Artists and Writers Club, Lagos and Ibadan, Nigeria (*Migration* series).
1963 Terry Dintenfass Gallery, New York.
1965 Terry Dintenfass Gallery (*Nigerian* paintings).
Brandeis University, Waltham, Massachusetts.
1968 Terry Dintenfass Gallery (paintings for *Harriet and the Promised Land*).
Fisk University, Nashville, Tennessee (*Toussaint L'Ouverture* series).
1969 Studio Museum in Harlem, New York.
1973 Terry Dintenfass Gallery (*Builder* paintings).
State Capitol Museum, Olympia, Washington (*George Washington Bush* series).

Work in Public Collections

Addison Gallery of American Art, Andover, Massachusetts; Albright-Knox Art Gallery, Buffalo, New York; American Academy of Arts and Letters, New York; Atlanta University, Georgia; Brandeis University, Waltham, Massachusetts; Baltimore Museum of Art, Maryland; Birmingham Museum of Art, Alabama; The Brooklyn Museum, New York; Benedict College, Columbia, South Carolina; Bennett College, Greensboro, North Carolina; Carolina Art Association/Gibbes Art Gallery, Charleston, South Carolina; Container Corporation of America, Chicago; Detroit Institute of Arts, Michigan; First National City Bank, New York; First Pennsylvania Bank, Philadelphia; Fisk University, Nashville, Tennessee; George Washington Carver Museum, Tuskegee, Alabama; Hampton Institute, Virginia; The Hirshhorn Museum and Sculpture Garden, Smithsonian Institution, Washington, D. C.; Howard University, Washington, D. C.; IBM Corporation, New York; Marymount College, Tarrytown, New York; The Metropolitan Museum of Art, New York; Milwaukee Art Center, Wisconsin; Morgan State College Gallery of Art, Baltimore, Maryland; The Museum of Modern Art, New York; Museum of Modern Art, São Paulo, Brazil; National Collection of Fine Arts, Smithsonian Institution, Washington, D. C.; New Jersey State Museum, Trenton; New Orleans Museum of Art, Louisiana; North Carolina Museum of Art, Raleigh; The Phillips Collection, Washington, D. C.; Philadelphia Museum of Art; Portland Art Museum, Oregon; Museum of Art, Rhode Island School of Design, Providence; University Galleries, Southern Illinois University at Carbondale; State Capitol Museum, Olympia, Washington; Andrew Dickson White Museum of Art at Cornell University, Ithaca, New York; University Art Museum, Berkeley, California; University of Arizona Museum of Art, Tucson; University of Georgia, Athens; University of Nebraska at Lincoln; Virginia Museum of Fine Arts, Richmond; Walker Art Center, Minneapolis; Whitney Museum of American Art, New York; Wichita Art Museum, Kansas, The Roland P. Murdock Collection; Worcester Art Museum, Massachusetts.

Catalogue

Works are arranged chronologically.
Measurements are in inches, height preceding width.
Asterisks denote works exhibited at the Whitney Museum only.

1. *Street Orator.* 1936.
 Casein on paper.
 23½ x 18.
 Lent by Mrs. Jacob Lawrence.

2. *Free Clinic.* 1937.
 Casein on paper.
 29 x 30.
 Lent by Mrs. Jacob Lawrence.

3. *Rain.* 1937.
 Casein on paper.
 29 x 21.
 Lent by Mrs. Jacob Lawrence.

4. *Bar N' Grill.* 1937.
 Casein on paper.
 29 x 29½.
 Lent by Mrs. Jacob Lawrence.

Toussaint L'Ouverture Series. 1937-38. (41 paintings.)
Tempera on paper.
Lent by the Department of Art, Fisk University,
Nashville, Tennessee.

5. *No. 2.* Mistreatment by the Spanish soldiers caused much trouble on the island and caused the death of Anacanca, a native queen, 1503.
 11 x 19.

6. *No. 9.* He read Rynol's Anti-Slavery Book that predicted a Black Emancipator, which language spirited him, 1763-1776.
 19 x 11.

7. *No. 17.* Toussaint captured Marmalade, held by Vernet, a mulatto, 1795.
 19 x 11.

8. *No. 20.* General Toussaint L'Ouverture, Statesman and Military Genius esteemed by the Spaniards, feared by the English, dreaded by the French, hated by the planters, and reverenced by the Blacks.
 19 x 11.

9. *No. 23.* General L'Ouverture collected forces at Marmalade and on October 9, 1794, left with 500 men to capture San Miguel.
 11 x 19.

10. *No. 36.* During the truce Toussaint is deceived and arrested by LeClerc. LeClerc led Toussaint to believe that he was sincere, believing that when Toussaint was out of the way, the Blacks would surrender.
 11 x 19.

11. *No. 38.* Napoleon's attempt to restore slavery in Haiti was unsuccessful. Desalines, Chief of the Blacks, defeated LeClerc. Black men, women, and children took up arms to preserve their freedom, November, 1802.
 11 x 19.

12. *No. 41.* Desalines was crowned Emperor October 4, 1804, thus: Jean Jacques the First of Haiti. Desalines, standing beside a broken chain, was dictator—as opposed to Toussaint's more liberal leadership.
 19 x 11.

13. *Fire Escape.* 1938.
 Gouache on paper.
 12¼ x 10⅞.
 Lent by Mr. and Mrs. Norman Lewis.

14. *Untitled.* 1938.
 Gouache on paper.
 12⅞ x 11⅜.
 Lent by Mr. and Mrs. Norman Lewis.

Frederick Douglass Series. 1938-39. (32 paintings.)
Tempera on masonite.
Lent by the Hampton Institute, Virginia.

Frederick Douglass Series, *Part I. The Slave.*

15. *No. 1.* In Talbot County, Eastern Shore, State of Maryland, in a thinly populated worn out district, inhabited by a white population of the lowest order, among slaves who in point of ignorance were fully in accord with their surrounding. It was here that Frederick Douglass was born and spent the first years of his childhood—February, 1817.
12 x 17⅞.

16. *No. 2.* One of the barbarous laws of the slave system was that of hiring members out of families who were slaves, this occurring in the Douglass family; the only recollection he had of his mother were those few hasty visits she made him during the night.
12 x 17⅞.

17. *No. 3.* When old enough to work he was taken to the slave master Col. Lloyd; his first introduction to the realities of the slave system was the flogging of Millie, a slave on the Lloyd plantation.
12 x 17⅞.

18. *No. 4.* In the slaves' living quarters, the children slept in holes and corners of the huge chimneys; old and young, married and single, slept on clay floors.
12 x 17⅞.

19. *No. 5.* The master's quarters or the great house was filled with luxuries, it possessed the finest of foods from Europe, Asia, Africa and the Caribbeans. It contained fifteen servants, it was one of the finest mansions in the South.
17⅞ x 12.

20. *No. 6.* Hired out from Col. Lloyd's plantation—Frederick Douglass arrived in Baltimore at the age of nine. His new mistress never before being a slave holder she consented to his request to teach him to read, to which the master of the house told her the laws of the slave system. One being a slave must only learn one thing—to obey—1826.
12 x 17⅞.

21. *No. 7.* Douglass forced by his master to discontinue his learning, continued his studies with his white friends who were in school.
17⅞ x 12.

22. *No. 8.* Frederick Douglass having earned a few cents as a bootblack purchased the Columbian Orator. In this book he studied Sheridan's speeches on the American war and speeches by the great William Pitt and Fox.
17⅞ x 12.

23. *No. 9.* Transferred back into the Eastern shore of Maryland, being one of the few Negroes who could read or write, Douglass was approached by James Mitchell, a free Negro, and asked to help teach a Sabbath-School. However their work was stopped by a mob who threatened them with death if they continued their class—1833.
12 x 17⅞.

24. *No. 10.* The master of Douglass seeing he was of a rebellious nature sent him to a Mr. Covey, a man who had built up a reputation as a "nigger breaker." A second attempt to flog Douglass by Covey was unsuccessful. This was one of the most important incidents in the life of Frederick Douglass. He was never attacked again by Covey. His philosophy: A slave easily flogged is flogged oftener—a slave who resists flogging is flogged less.
12 x 17⅞.

25. *No. 11.* The slaves were invariably given a Christmas and New Year's Holiday, which they spent in various ways, such as hunting, ball playing, boxing, foot racing, dancing, and drinking. The latter being encouraged the most by the slave holders. This being the most effective way of keeping down the spirit of insurrection among slaves.
17⅞ x 12.

26. *No. 12.* It was in the year 1836 that Douglass conceived a plan of escape, also influencing several slaves around him. He told his co-conspirators what had been done, dared and suffered by men to obtain the inestimable boon of liberty.
17⅞ x 12.

27. *No. 13.* As the time of their intended escape drew nearer, their anxiety grew more and more intense. Their food was prepared and their clothing packed. Douglass had forged their passes. Early in the morning they went into the fields to work. In mid-day they were all called off the field only to discover that they had been betrayed.
12 x 17⅞.

28. *No. 14.* Frederick Douglass was sent to Baltimore to work in the ship yards of Gardiner, here the workers were Negro slaves and a poor class of whites. The slaveholders caused much friction between the two groups. It was in one of the many brawls that issued here that Douglass almost lost an eye.

No. 15. Douglass had become a master of his trade, that of ship caulker. Seeing no reason why at the end of each week he should give his complete earnings to a man he owed nothing—again he planned escape.
(There is only one painting to illustrate these two episodes.)
17⅞ x 12.

Frederick Douglass Series, *Part II. The Fugitive.*

29. *No. 16.* Frederick Douglass' escape from slavery was a hazardous and an exciting 24 hours. Douglass disguised as a sailor, best he thought, because he knew the language of a sailor, he knew a ship from stem to stern. On he traveled through Maryland, Wilmington, Philadelphia and his destination, New York. Frederick Douglass was free.
17⅞ x 12.

30. *No. 17.* Douglass' first three years in the North were spent as a laborer, on the wharfs, sawing wood, shoveling coal, digging cellars and removing rubbish.
12 x 17⅞.

31. *No. 18.* Douglass listened to lectures by William Lloyd Garrison. He heard him denounce the slave system in words that were mighty in truth and mighty in earnestness.
17⅞ x 12.

32. *No. 19.* It was in the year 1841 that Frederick Douglass joined the forces of Lloyd Garrison and the abolitionists. He helped secure subscribers to the *Anti-Slavery Standard* and the *Liberator*. He lectured through the Eastern counties of Massachusetts narrating his life as a slave, telling of the cruelty, inhumane and clannish acts of the slave system.
12 x 17⅞.

33. *No. 20.* The Garrisonians in the year 1843, planned a series of conventions in order to spread and create greater antislavery sentiment in New Hampshire, Vermont, New York, Ohio, Indiana, and Pennsylvania. In one of these conventions Douglass and two of his fellow workers were mobbed at Pendleton.
12 x 17⅞.

34. *No. 21.* Frederick Douglass left America to lecture in Great Britain. Here he met some of the most progressive and liberal minded men in the English speaking world. He made a great speech in Covent Garden Theatre on August 7, 1846, in which speech he told of the people he represented, how at that moment there were three million colored slaves in the United States.
17⅞ x 12.

35. *No. 22.* Leaving England in the Spring of 1847 with a large sum of money given him by sympathizers of the Anti-Slavery movement, he arrived in Rochester, New York and edited the first Negro paper "The North Star." As editor of the "North Star," he wrote of the many current topics affecting the Negro such as the Free Soil Convention at Buffalo, the nomination of Martin Van Buren, the Fugitive Slave Law, and the Dred Scott Decision.
17⅞ x 12.

36. *No. 23.* Another important branch of Frederick Douglass' anti-slave work was the underground railroad, of which he was the station master for Rochester, controlling the Lake Ontario and Queen's Dominions.
12 x 17⅞.

37. *No. 24.* It was in 1847 at Rochester, New York, that Frederick Douglass first met Captain John Brown, one of the strongest fighters for the abolishment of slavery. Here John Brown talked with Douglass on his plan to fight slavery. He had been long looking for a man such as Douglass, as an admirer and champion of Negro rights—he had found the man.
12 x 17⅞.

38. *No. 25.* John Brown discussed with Frederick Douglass his plan to attack Harper's Ferry, an arsenal of the United States Government. Brown's idea was to attack the arsenal and seize the guns. Douglass argued against this plan, his reason being that the abolishment of slavery should not occur through revolution.
12 x 17⅞.

39. *No. 26.* With Abraham Lincoln of the Republican party elected President of the United States, with states threatening their withdrawal from the Union—thus the country was in war fever—the abolitionists made their speeches frequently— and were more often attacked by those who relished slavery.
12 x 17⅞.

40. *No. 26.* The North and South were at war. Governor Andrews of Massachusetts asked the help of Frederick Douglass to help him secure two colored regiments. Douglass spoke before the colored men of Massachusetts. He told them that a war fought for the perpetual enslavement of the colored people —called logically and loudly for colored men to help supress it. He brought to their memories Denmark Vessey, Nat Turner, Shields Green and Copeland who fought side by side with John Brown. The 54th and 55th colored regiments were mustered.
17⅞ x 12.

41. *No. 27.* Having assured colored men that if they went into battle field, that their treatment would be the same as the whites, the government not keeping its promise, Douglass protested and his protest led him to Washington and to President Lincoln, who proving to be a man of great human qualities, gave Frederick Douglass a great deal of confidence and encouragement. Douglass left with the feeling that the black man's salvation was on the battle field.
17⅞ x 12.

42. *No. 29.* A cowardly and bloody riot took place in New York in July 1863. A mob fighting the draft, a mob willing to fight to free the union, a mob unwilling to fight to free slaves, a

53

mob who attacked every colored person within reach disregarding sex or age, hanged Negroes, burned their homes, bashed out the brains of young children against lamp posts. The colored populace took refuge in cellars and garrets. This mob was a part of the rebel force, without the rebel uniform, but with all its deadly hate, it was the fire of the enemy in the rear of the loyal army.
12 x 17⅞.

Frederick Douglass Series, *Part III. The Free Man.*

43. *No. 30.* The war was over. The slaves were literally turned out by their masters into a world unknown to them. Here they had ceased to be the slaves of nature.
17⅞ x 12.

44. *No. 31.* An appointment to any important and lucrative office under the United States Government usually brings its recipient a large measure of praise and congratulations on one hand and much abuse and disparagement on the other. With these two conditions prevailing, Frederick Douglass was appointed by President Rutherford B. Hayes, United States Marshal of the District of Columbia, 1877.
17⅞ x 12.

45. *No. 32.* During the exodus thousands of poor Negroes left the South in search of better country. Douglass spoke of this movement at the Social Science Congress at Saratoga. "The habit of a roaming from place to place is never a good one until a man has endeavored to make his immediate surrounding in accord with his wishes. The business of this Government is to protect its citizens where they are and not send them where they do not need protection."
12 x 17⅞.

46. *No. 33.* Frederick Douglass revisited the Eastern Shore of Maryland—here he was born a slave—now he returned a free man. He left unknown to the outside world, and returned well known. He left on a freight boat, and returned on the *United States of America.*
17⅞ x 12.

47. *Interior.* 1939.
Casein on paper.
35½ x 31.
Lent by Mrs. Jacob Lawrence.

Harriet Tubman Series. 1939-40. (31 paintings.)
Tempera on masonite.
Lent by the Hampton Institute, Virginia.

48. *No. 2.* "I am no friend of slavery, but I prefer the liberty of my own country to that of another people, and the liberty of my own race to that of another race. The liberty of the descendants of Africa in the United States is incompatible with the safety and liberty of the European descendants. Their slavery forms an exception (resulting from a stern and inexorable necessity) to the general liberty in the United States."
—Henry Clay
17⅞ x 12.

49. *No. 4.* On a hot summer day about 1821 a group of slave children were tumbling in the sandy soil in the state of Maryland—and among them was one, Harriet Tubman.
—Dorchester County, Maryland
12 x 17⅞.

50. *No. 7.* Harriet Tubman worked as water girl to cotton pickers; she also worked at plowing, carting, and hauling logs.
17⅞ x 12.

51. *No. 9.* Harriet Tubman dreamt of freedom—("Arise! Flee for your life!") and in the visions of the night she saw the horsemen coming, beckoning hands were ever motioning her to come, and she seemed to see a line dividing the land of slavery from the land of freedom.
12 x 17⅞.

52. *No. 18.* At one time during Harriet Tubman's expedition into the South, the pursuit after her was very close and vigorous. The woods were scoured in all directions, and every person was stopped and asked: "Have you seen Harriet Tubman?"
17⅞ x 12.

53. *No. 20.* In 1857 the fugitive slave law was passed, which bound the people north of the Mason Dixon Line to return to bondage any fugitives found in their territories, forcing Harriet Tubman to carry her escaped slaves into Canada.
17⅞ x 12.

54. *No. 26.* In 1860 the first gun was fired on Fort Sumter, and the war of the Rebellion was on.
17⅞ x 12.

55. *No. 29.* She nursed the Union soldiers and knew how, when they were dying by large numbers of some malignant disease, with cunning skill to extract from roots and herbs which grew near the source of the disease, the healing draught, which allayed the fever and restored numbers to health.
12 x 17⅞.

Migration Series. 1940-41. (60 paintings.)
Tempera on masonite.

56. *No. 1.* During the World War there was a great migration North by Southern Negroes.
 12 x 18.
 Lent by The Phillips Collection, Washington, D. C.

57. *No. 3.* In every town Negroes were leaving by the hundreds to go North and enter into the Northern industry.
 12 x 18.
 Lent by The Phillips Collection, Washington, D. C.

58. *No. 7.* The Negro, who had been part of the soil for many years, was now going into and living a new life in the urban centers.
 18 x 12.
 Lent by The Phillips Collection, Washington, D. C.

59. *No. 11.* In many places because of the war, food had doubled in price.
 18 x 12.
 Lent by The Phillips Collection, Washington, D. C.

60. *No. 13.* Due to the South's losing much of its labor, the crops were left to dry and spoil.
 12 x 18.
 Lent by The Phillips Collection, Washington, D. C.

61. *No. 16.* Although the Negro was used to lynching, he found this an opportune time for him to leave where one had occurred.
 18 x 12.
 Lent by The Museum of Modern Art, New York; Gift of Mrs. David M. Levy, 1942.

62. *No. 18.* The migration gained in momentum.
 18 x 12.
 Lent by The Museum of Modern Art, New York; Gift of Mrs. David M. Levy, 1942.

63. *No. 21.* Families arrived at the station very early in order not to miss their trains North.
 12 x 18.
 Lent by The Phillips Collection, Washington, D. C.

64. *No. 39.* Luggage crowded the railroad platforms.
 18 x 12.
 Lent by The Phillips Collection, Washington, D. C.

65. *No. 42.* They also made it very difficult for migrants leaving the South. They often went to railroad stations and arrested the Negroes wholesale, which in turn made them miss their trains.
 18 x 12.
 Lent by The Museum of Modern Art, New York; Gift of Mrs. David M. Levy, 1942.

66. *No. 48.* Housing for the Negroes was a very difficult problem.
 18 x 12.
 Lent by The Museum of Modern Art, New York; Gift of Mrs. David M. Levy, 1942.

67. *No. 50.* Race riots were very numerous all over the North because of the antagonism that was caused between the Negro and white workers. Many of these riots occurred because the Negro was used as a strike breaker in many of the Northern industries.
 18 x 12.
 Lent by The Museum of Modern Art, New York; Gift of Mrs. David M. Levy, 1942.

68. *No. 55.* The Negro, being moved suddenly from out-of-doors and cramped into urban life, contracted a great deal of tuberculosis. Because of this, the death rate was very high.
 12 x 18.
 Lent by The Phillips Collection, Washington, D. C.

69. *No. 57.* The female worker was also one of the last groups to leave the South.
 18 x 12.
 Lent by The Phillips Collection, Washington, D. C.

70. *No. 58.* In the North the Negro had better educational facilities.
 12 x 18.
 Lent by The Museum of Modern Art, New York; Gift of Mrs. David M. Levy, 1942.

71. *Catholic New Orleans.* 1941.
 Gouache on paper.
 17⅞ x 23¾.
 Lent by the University Art Museum, Berkeley, California; purchased with the aid of funds from the National Endowment for the Arts (selected by The Committee on the Acquisition of Afro-American Art).

72. *The Green Table.* 1941.
 Gouache on paperboard.
 16½ x 22½.
 Lent by Mr. and Mrs. John Marin, Jr.

John Brown Series. 1941. (22 paintings.)
Gouache on paper.
Lent by The Detroit Institute of Arts; Gift of Mr. and Mrs. Milton Lowenthal, 1955.

*73. *No. 6.* John Brown formed an organization among the colored people of the Adirondacks woods to resist the capture of any fugitive slaves.
 20 x 14.

*74. *No. 7.* To the people he found worthy of trust, he communicated his plans.
14 x 20.

*75. *No. 8.* John Brown's first thought of the place where he would make his attack came to him while surveying land for Oberlin College in West Virginia, 1840.
14 x 20.

*76. *No. 21.* After John Brown's capture, he was put on trial for his life in Charleston, Virginia.
20 x 14.

*77. *No. 22.* John Brown was found "Guilty of treason and murder in the first degree." He was hanged in Charleston, Virginia, on December 2, 1859.
20 x 14.

78. *Firewood.* 1942.
Watercolor on paper.
21 x 29.
Lent by the National Collection of Fine Arts, Smithsonian Institution, Washington, D. C.

*79. *Wash Day.* 1942.
Gouache on paper.
28½ x 20¼.
Lent by Mr. and Mrs. Sidney L. Bergen.

80. *The Plowman.* 1942.
Tempera on board.
20½ x 28¾.
Lent by Mr. and Mrs. Fred D. Rudin.

81. *Reflections.* 1942.
Gouache on paper.
28 x 21.
Lent by the First Pennsylvania Bank, Philadelphia.

82. *Pool Parlor.* 1942.
Gouache on paper.
31 x 22¾.
Lent by The Metropolitan Museum of Art, New York; Arthur H. Hearn Fund, 1942.

83. *Tombstones.* 1942.
Gouache on paper.
30 x 22.
Collection of the Whitney Museum of American Art, N. Y.

84. *Cafe Scene.* 1942.
Watercolor on paper.
19½ x 27.
Lent by the University of Arizona Museum of Art, Tucson; C. Leonard Pfeiffer Collection.

Harlem Series. 1942-43. (30 paintings.)
Watercolor on paper.

*85. *No. 1.* This is Harlem.
14⅜ x 21⅞.
Lent by The Hirshhorn Museum and Sculpture Garden, Smithsonian Institution, Washington, D. C.

86. *No. 2.* Most of the people are very poor.
21¼ x 14¼.
Lent by Pietro Belluschi.

87. *No. 5.* Often three families share one toilet.
21¼ x 14¼.
Lent by Stephen V. Baldwin.

88. *No. 8.* The children go to school.
14¼ x 21¼.
Lent by Mr. and Mrs. Arthur J. Steel.

89. *No. 27.* Mothers and fathers work hard to educate their children.
14¼ x 21¼.
Lent by the New Jersey State Museum, Trenton; Gift of the Friends of the New Jersey State Museum.

90. *Sidewalk Drawings.* 1943.
Gouache on paper.
21⅝ x 29½.
Lent by Mr. and Mrs. Jan de Graaff.

91. *Woman with Grocery Bags.* 1943.
Gouache on paper.
30 x 21.
Lent by Charles Gwathmey.

*92. *End of the Day.* 1945.
Gouache on paper.
20 x 29½.
Lent by Mr. and Mrs. Edward F. Kook.

*93. *Seaman's Belt.* 1945.
Gouache on paper.
21 x 29.
Lent by the Albright-Knox Art Gallery, Buffalo, New York; The Martha Jackson Collection, promised gift.

94. *The Seamstress.* 1946.
Gouache on paper.
21⅝ x 29⅞.
Lent by University Galleries, Southern Illinois University at Carbondale.

*95. *Barber Shop.* 1946.
Gouache on paper.
21 x 29½.
Lent by Mrs. G. Richard Davis.

96. *The Lovers.* 1946.
Gouache on paper.
21½ x 30.
Lent by Mrs. Harpo Marx.

97. *Shooting Gallery.* 1946.
Gouache on paper.
21½ x 29½.
Lent by the Walker Art Center, Minneapolis; Gift of Dr. and Mrs. Malcolm McCannel.

98. *Accident.* 1946.
Gouache on paper.
22 x 30.
Lent by the Carolina Art Association/Gibbes Art Gallery, Charleston, South Carolina.

99. *Going Home.* 1946.
Gouache on paperboard.
21½ x 29½.
Lent by IBM Corporation, New York.

100. *Beer Hall.* 1947.
Tempera on gesso panel.
20 x 29.
Lent by Mr. and Mrs. Max Gordon.

101. *Catfish Row.* 1947.
Tempera on gesso panel.
18 x 24.
Lent by Mr. and Mrs. Robert D. Straus.

*102. *Red Earth.* 1947.
Tempera on gesso panel.
20 x 24.
Lent by Mr. and Mrs. J. Banks.

War Series. 1947. (14 paintings.)
Egg tempera on gesso panel.
Collection of the Whitney Museum of American Art, New York; Gift of Mr. and Mrs. Roy R. Neuberger.

103. *No. 1. Prayer.*
16 x 20.

104. *No. 2. Shipping Out.*
20 x 16.

105. *No. 3. Another Patrol.*
16 x 20.

106. *No. 6. The Letter.*
20 x 16.

107. *No. 8. Beachhead.*
16 x 20.

108. *No. 12. Going Home.*
16 x 20.

109. *Summer Street Scene.* 1948.
Tempera on gesso panel.
20 x 24.
Lent by Alfred E. Jones, Jr.

110. *(Broadway) Playland.* 1949.
Tempera on gesso panel.
24 x 20.
Lent by Atlanta University, Georgia.

111. *Sedation.* 1950.
Casein on paper.
31 x 22⅞.
Lent by The Museum of Modern Art, New York; Gift of Mr. and Mrs. Hugo Kastor.

112. *Depression.* 1950.
Casein on paper.
22 x 30½.
Collection of the Whitney Museum of American Art, New York.

113. *Square Dance.* 1950.
Casein on paper.
22 x 30.
Lent by Leonard and Mary Schlosser.

*114. *In the Garden.* 1950.
Casein on paper.
22 x 30.
Lent by Dr. and Mrs. Abram Kanof.

115. *Slums.* 1950.
Gouache on paper.
25 x 21½.
Lent by Mr. and Mrs. William A. Marsteller.

116. *Photographer's Shop.* 1951.
Watercolor and gouache on paper.
23 x 32.
Lent by the Milwaukee Art Center, Wisconsin.

*117. *Chess on Broadway.* 1951.
Watercolor and gouache on paper.
21½ x 24½.
Lent by Mrs. Victor S. Riesenfeld.

*118. *Vaudeville.* 1952.
Tempera and pencil on gesso panel.
29⅞ x 20.
Lent by The Hirshhorn Museum and Sculpture Garden, Smithsonian Institution, Washington, D. C.

119. *Tragedy and Comedy*. 1952.
Tempera on gesso panel.
24 x 30.
Lent by Mr. and Mrs. Alan Brandt.

120. *Night After Night*. 1952.
Tempera on gesso panel.
24 x 18.
Lent by Dr. and Mrs. Herbert J. Kayden.

121. *Surgery, Harlem Hospital*. 1953.
Tempera on gesso panel.
20 x 24.
Lent by Dr. Cyril C. Ollivierre.

122. *Card Game*. 1953.
Tempera on gesso panel.
19¾ x 19.
Lent by Dr. and Mrs. Herbert J. Kayden.

123. *Village Quartet*. 1954.
Tempera on gesso panel.
9 x 12.
Lent by Mr. and Mrs. John C. Denman.

124. *Pool*. 1954.
Tempera on gesso panel.
10 x 13⅞.
Lent by The Hirshhorn Museum and Sculpture Garden, Smithsonian Institution, Washington, D. C.

125. *Man With Flowers*. 1954.
Tempera on gesso panel.
15½ x 11½.
Lent by Leonard and Ruth Bocour.

*126. *Study for U.N. Mural*. 1955.
Casein-gouache on paper.
29 x 72.
Lent by Mr. and Mrs. Sherle Wagner.

Struggle Series: *From the History of the American People*.
1955-56. (30 paintings.)
Tempera on gesso panel.

127. *No. 2. Massacre in Boston*.
18½ x 22½.
Lent by Mr. and Mrs. Lewis G. Lehr.

128. *No. 5. (Slave Revolt.)* . . . for freedom we want and will have, for we have served this cruel land long enuff . . .
—A Georgia Slave, 1810.
16 x 12.
Lent by Mr. and Mrs. Oscar Rosen.

*129. *No. 6. (Independence.)* . . . we mutually pledge to each other our Lives, our Fortunes, and our sacred Honour.
—4 July 1776.
16 x 12.
Lent by Mr. and Mrs. Louis Harrow.

130. *No. 9. Defeat*.
12 x 16.
Lent by Dr. Robert Aaron.

131. *No. 15. (Creation.)* We, the people of the United States, in order to form a more perfect Union, establish justice, insure domestic tranquility . . . —17 September 1787
18½ x 22½.
Lent by Mr. and Mrs. Sidney Sass.

132. *No. 21. (Tippecanoe.)* Listen, Father! The Americans have not yet defeated us by land; neither are we sure they have done so by water—we therefore wish to remain here and fight our enemy . . .
—Tecumseh to the British, Tippecanoe, 1811.
18½ x 22½.
Lent by Michael B. Kapon, Acker, Merrall and Condit Company, New York.

133. *No. 24. (The Burning of Washington.)* Of the Senate House, the President's Palace, the barracks, the dockyard . . . nothing could be seen except heaps of smoking ruins
—A British Officer at Washington, 1814.
18½ x 22½.
Lent by Terry Dintenfass, Inc., New York.

*134. *Cabinet Maker*. 1957.
Casein on paper.
30½ x 22⅝.
Lent by The Hirshhorn Museum and Sculpture Garden, Smithsonian Institution, Washington, D. C.

135. *Playroom*. 1957.
Tempera on gesso panel.
16 x 12.
Lent by the William H. Lane Foundation.

136. *Two Comedians and a Dancer*. 1958.
Tempera on gesso panel.
18 x 24.
Lent by Mrs. G. Macculloch Miller.

137. *Street Shadows*. 1959.
Tempera on gesso panel.
24 x 30.
Lent by Jewel and Lewis Garlick.

138. *Fruits and Vegetables.* 1959.
Tempera on gesso panel.
20 x 24.
Lent by Mrs. Renée Grossberg.

139. *The Brown Angel.* 1959.
Tempera on gesso panel.
24 x 20.
Lent by Mr. and Mrs. Irving Levick.

*140. *The Library II.* 1960.
Tempera on gesso panel.
24 x 30.
Lent by Dr. and Mrs. Martin Cherkasky.

*141. *The Library III.* 1960.
Tempera on gesso panel.
30 x 24.
Lent by the First National City Bank, New York.

*142. *The Ordeal of Alice.* 1963.
Tempera on gesso panel.
$19\frac{7}{8}$ x $23\frac{7}{8}$.
Lent by Dr. and Mrs. Herbert J. Kayden.

143. *Taboo.* 1963.
Tempera on gesso panel.
$19\frac{7}{8}$ x $23\frac{7}{8}$.
Lent by Mr. and Mrs. Josef Jaffe.

*144. *Antiquities.* 1964.
Gouache on paper.
$30\frac{3}{4}$ x 22.
Lent by the Morgan State College Gallery of Art, Baltimore, Maryland.

145. *Three Red Hats.* 1964.
Gouache on paper.
22 x $30\frac{3}{4}$.
Lent by Mrs. J. E. Spingarn.

146. *Meat Market.* 1964.
Gouache on paper.
$30\frac{3}{4}$ x 22.
Lent by Judith Golden.

147. *The Family.* 1964.
Tempera on gesso panel.
24 x 20.
Lent by Mr. and Mrs. Arthur Kobacker.

*148. *Dreams No. 1.* 1965.
Casein-gouache on paper.
35 x 28.
Lent by Ruth and Jack Wexler.

149. *Market Place No. 1.* 1966.
Gouache on paper.
$10\frac{1}{2}$ x $14\frac{3}{4}$.
Lent by Sidney Frauwirth.

150. *Labor* (Illustration for *Harriet and the Promised Land*). 1967.
Gouache on paper.
11 x $11\frac{1}{4}$.
Lent by Mr. and Mrs. Warren Shapleigh.

151. *Walking by Day, Sleeping by Night* (Illustration for *Harriet and the Promised Land*). 1967.
Gouache on paper.
$16\frac{1}{4}$ x 25.
Lent by David Ross.

152. *Canada Bound* (Illustration for *Harriet and the Promised Land*). 1967.
Gouache on paper.
14 x $25\frac{1}{2}$.
Lent by Dr. and Mrs. James L. Curtis.

153. *A Foothold on the Rocks.* 1967.
Tempera on gesso panel.
30 x 24.
Lent anonymously.

154. *Builders No. 2.* 1969.
Casein-gouache on paper.
30 x 22.
Lent by Mrs. B. J. Ronis.

155. *Munich Olympic Games.* 1971.
Gouache on board.
43 x $27\frac{1}{4}$.
Lent by Joseph M. Erdelac.

156. *Builders No. 1.* 1971.
Casein-gouache on paper.
30 x 22.
Lent by the Birmingham Museum of Art, Alabama.

157. *The Builder No. 1.* 1973.
Casein-gouache on paper.
$28\frac{7}{8}$ x $23\frac{7}{8}$.
Lent by Sidney Deutsch.

158. *Builders No. 4.* 1973.
Casein-gouache on paper.
20 x 29.
Lent by the New Orleans Museum of Art, Louisiana.

George Washington Bush Series. 1973. (5 paintings.)
Casein-gouache on board.
Lent by the State Capitol Museum, Olympia, Washington.

159. *No. 1.* On a fair May morning in 1844, George Washington Bush, his family and four other families, left Clay County, Missouri, in six Conestoga wagons.
48 x 36.

160. *No. 2.* In the Iowa territory, they rendezvoused with a wagon train headed for the Oregon Trail.
48 x 36.

161. *No. 3.* The hardest part of the journey is yet to come—the Continental Divide, stunned by the magnitude of roaring rivers.
48 x 48.

162. *No. 4.* Christmas 1844, Fort Vancouver is a temporary halting place before they venture to the Puget Sound country.
48 x 36.

163. *No. 5.* "Thank God All Mighty, home at last!"—the settlers erect shelter at Bush Prairie near what is now Olympia, Washington, November 1845.
48 x 36.

164. *Poster Design . . . Whitney Exhibition, 1974.*
Gouache on paper.
30 x 22.
Lent by Terry Dintenfass, Inc., New York.

Selected Bibliography
Compiled by Louise A. Parks

Books Illustrated by the Artist

Aesop's Fables. New York: Windmill Books, 1970.

Hughes, Langston. *One Way Ticket.* New York: Alfred A. Knopf, 1948.

Lawrence, Jacob. *Harriet and the Promised Land.* New York: Windmill Books, Simon and Schuster, 1968.

Transcript

Greene, Carroll. "Interview with Jacob Lawrence," October 25 and November 26, 1969. New York: Archives of American Art, Smithsonian Institution.

Books

Baur, John I. H., ed. *New Art in America.* Essay on Jacob Lawrence by Frederick S. Wright. Greenwich, Conn.: New York Graphic Society, 1957. Pp. 272-75, 4 il.

Bearden, Romare, and Henderson, Harry. *Six Black Masters of American Art.* Garden City, N.Y.: Doubleday, 1972. Pp. 99-119, 10 il.

Bearden, Romare, and Holty, Carl. *The Painter's Mind.* New York: Crown Publishers. P. 209, 1 il.

Bethers, Ray. *Pictures, Painters and You.* New York: Pitman Publishing Corp., 1948. Pp. 240, 241.

Eliot, Alexander. *300 Years of American Painting.* New York: Time Inc., 1957. Pp. 260, 261, 1 il.

Fax, Elton C. *Seventeen Black Artists.* New York: Dodd, Mead and Co., 1971. Pp. 146-66.

Feldman, Edmund Burke. *Varieties of Visual Experience.* Englewood Cliffs, N.J.: Prentice-Hall, 1967. Pp. 49-50, 1 il.

Fine, Elsa Honig. *The Afro-American Artist: A Search for Identity.* New York: Holt, Rinehart and Winston, 1973. P. 150, 1 il.

Gardner, Albert Ten Eyck. *History of Water Color Painting.* New York: Reinhold Publishing Corp., 1966. P. 156, 1 il.

Goodrich, Lloyd, and Baur, John I. H. *American Art of Our Century.* New York: Praeger Publishers, 1961. Pp. 160-61, 3 il.

Green, Samuel M. *American Art: A Historical Survey.* New York: Ronald Press Co., 1966. Pp. 566, 571-72.

Gruskin, Alan D. *Painting in the U.S.A.* Garden City, N.Y.: Doubleday, 1946. P. 83.

Hills, L. Rust, and Gordon, John, eds. *New York, New York.* New York: Shorecrest, 1965. P. 403, 1 il.

Larkin, Oliver W. *Art and Life in America.* 2nd ed. New York: Holt, Rinehart and Winston, 1960. Pp. 428, 436-37, 466, 488, 1 il.

Lewis, Samella, and Waddy, Ruth. *Black Artists on Art.* Vol. 2. Los Angeles: Contemporary Crafts, 1971. Pp. 80-82, 2 il.

Lipman, Jean, ed. *What Is American in American Art.* New York: Art in America, 1963. P. 173, 1 il.

Locke, Alain L. *The Negro in Art.* Washington, D. C.: Associates in Negro Folk Education, 1940. Pp. 127-29, 133.

McCurdy, Charles, ed. *Modern Art.* New York: Macmillan, 1959. Pp. 144, 170, 1 il.

McLanathan, Richard. *The American Tradition in the Arts.* New York: Harcourt, Brace and World, 1968. P. 143.

Mendelowitz, Daniel M. *A History of American Art.* 2nd ed. New York: Holt, Rinehart and Winston, 1970. Pp. 412, 415, 1 il.

Nordness, Lee, ed. *Art: U.S.A.: Now.* New York: Viking Press, distrib., 1962. Pp. 320-23, 5 il.

Pearsons, Ralph M. *Critical Appreciation Course II.* Nyack, N.Y.: Design Workshop, 1950. Pp. 116-19, 6 il.

Pierson, William H., Jr., and Davidson, Martha, eds. *Arts of the United States.* New York: McGraw-Hill, 1960. Pp. 80, 349, 3 il.

Porter, James A. *Modern Negro Art.* New York: Arno Press, 1969. Pp. 151-52, 6 il.

Puma, Fernando. *Modern Art Looks Ahead.* New York: Beachhurst Press, 1947. P. 16, 1 il.

Richardson, Ben Albert. *Great American Negroes.* Rev. ed. New York: Thomas Y. Crowell Co., 1956. Pp. 102-10.

Richardson, E. P. *Painting in America.* New York: Thomas Y. Crowell Co., 1956. P. 410.

Rodman, Selden. *Conversations with Artists.* New York: Devin-Adair, 1957. Pp. 204-207, 223, 224.

Shapiro, David, ed. *Social Realism: Art as a Weapon.* New York: Frederick Ungar Publishing Co., 1973. Pp. 215-47.

Standard References

The American Library Compendium and Index of World Art. New York: American Archives of World Art, 1961. P. 229.

American Painting 1900-1970. New York: Time-Life Books, 1970. Pp. 93, 100, 1 il.

The Britannica Encyclopaedia of American Art. Chicago: Encyclopaedia Britannica, 1973. P. 338.

Current Biography. Vol. 26 (July 1965). New York: H. W. Wilson Co. P. 18.

Larousse Encyclopedia of Modern Art. New York: Prometheus Press, 1965. P. 418.

McGraw-Hill Dictionary of Art. Vol. 3. New York: McGraw-Hill, 1969. P. 391.

Monro, Isabel Stevenson, and Monro, Kate M. *Index to Reproductions of Paintings.* New York: H. W. Wilson Co., 1948. P. 380. First Supplement, 1964. P. 257.

Phaidon Dictionary of Twentieth-Century Art. London, New York: Phaidon Press, 1973, P. 212.

Ploski, Harry A., and Brown, Rosco C., eds. *The Negro Almanac.* New York: Bellwether Publishing Co., 1967. P. 629.

Who's Who in American Art. New York: R. R. Bowker, 1973. P. 431.

Exhibition Catalogues

American Federation of Arts. *Jacob Lawrence.* New York, 1960.

The Art Gallery, Ballentine Hall, Fisk University. *The Toussaint L'Ouverture Series.* Nashville, Tenn., 1968.

The Downtown Gallery. *Harlem.* New York, 1943.

The Downtown Gallery. *John Brown.* New York, 1945.

The Museum of Modern Art. *The Artist as Adversary.* New York, 1971.

Museum of the National Center of Afro-American Artists. *Five Famous Black Artists* (Romare Bearden, Jacob Lawrence, Horace Pippin, Charles White, Hale Woodruff). Roxbury, Mass., 1970.

The Phillips Memorial Gallery. *Three Negro Artists—Horace Pippin, Jacob Lawrence, Richmond Barthé.* Washington, D. C., 1947.

University of Illinois, Urbana. *Contemporary American Painting and Sculpture.* Urbana, Ill., 1955.

Articles and Reviews

References are arranged chronologically. Asterisks indicate more important articles.

J.L. "The Negro Sympathetically Rendered by Lawrence," *Art News,* vol. 37, February 18, 1939, p.15.

"First Generation of Negro Artists," *Survey Graphics,* vol. 28, March 1939, p. 224, 2 il.

"Life of Toussaint," *Art Digest,* vol. 15, December 15, 1940, p. 12.

*"... and the Migrants Kept Coming," *Fortune,* vol. 24, November 1941, pp. 102-109, 26. il. Color portfolio reprinted separately.

Devree, Howard. "A Reviewer's Notebook," *The New York Times,* November 9, 1941, p. 10x.

"Picture Story of the Negro's Migration," *Art News,* vol. 40, November 15, 1941, p. 8.

"... and the Migrants Kept Coming," *South Today,* vol. 7, Spring 1942, p. 5.

"How We Live in South and North," *Survey Graphic,* vol. 31, November 1942, pp. 478-79, 4 il.

Frankfurter, Alfred. "Artists for Victory Exhibition: The Paintings," *Art News,* vol. 41, January 1, 1943, p. 8, 1 il.

"Attractions in the Galleries," *The* (New York) *Sun,* May 14, 1943, p. 26.

M.R. "Effective Protest by Lawrence of Harlem," *Art Digest,* vol. 17, May 15, 1943, p. 7, 1 il.

Devree, Howard. "From a Reviewer's Notebook," *The New York Times,* May 16, 1943, p. 12x.

Genauer, Emily. "Surrealist Artists Show Similar Trend," (New York) *World-Telegram,* May 22, 1943, p. 9.

Coates, Robert M. "In the Art Galleries," *The New Yorker,* vol. 19, May 29, 1943, p. 15.

"The Migration of the Negro," *Portland Museum Bulletin,* vol. 4, June 1943, p. 2.

Symason, Mayer. "Canvas and Film," *New Masses,* June 8, 1943, p. 29, 2 il.

"Artist in Harlem," *Vogue,* vol. 102, September 15, 1943, pp. 94-95, 5 il.

"Five Paintings Purchased," *Portland Museum Bulletin,* vol. 5, November 1943, p. 3.

Frost, Rosamund. "Encore by Popular Demand, The Whitney," *Art News,* vol. 22, December 1, 1943, p. 21, 1 il.

Genauer, Emily. "Navyman Lawrence's Works at Modern Art," (New York) *World-Telegram and Sun,* October 14, 1944, p. 9.

*Louchheim, Aline B. "Lawrence: Quiet Spokesman," *Art News,* vol. 43, October 15, 1944, p. 14, 3 il.

J. G. "Jacob Lawrence's Migrations," *Art Digest,* vol. 19, November 1, 1944, p. 7.

"Negro Art Scores Without Double Standards," *Art Digest,* vol. 19, February 1, 1945, p. 8, 1 il.

Berryman, Florence S. "News of Art and Artists: John Brown's Struggles," *The* (Washington, D.C.) *Sunday Star,* October 6, 1945, p. B-5.

*McCausland, Elizabeth. "Jacob Lawrence," *Magazine of Art,* vol. 38, November 1945, pp. 250-54, 9 il.

H. McB. "Attractions in the Galleries," *The* (New York) *Sun,* December 9, 1945, p. 7.

Burrows, Carlyle. "In the Art Galleries," (New York) *Herald Tribune,* December 9, 1945, p. 7.

Devree, Howard. "By Groups and One by One," *The New York Times,* December 9, 1945, p. 11x.

B.W. "Saga of John Brown," *Art Digest,* vol. 20, December 15, 1945, p. 17, 1 il.

"The Passing Shows," *Art News,* vol. 44, December 15, 1945, p. 23.

"Art: John Brown's Body," *Newsweek,* vol. 26, December 24, 1945, p. 87, 1 il.

Greene, Marjorie E. "Jacob Lawrence," *Opportunity,* Winter 1945, pp. 26-27, 2 il.

"Arizona Art Collection," *Life,* vol. 20, February 18, 1946, p. 76, 1 il.

Hess, Thomas B. "Veterans: Then and Now," *Art News,* vol. 45, May 1946, p. 45, 2 il.

"Negro Artists," *Life,* vol. 21, July 22, 1946, p. 65, 1 il.

Gibbes, Jo. "Britannica Inaugurates a Rotating Annual," *Art Digest,* vol. 21, October 1, 1946, p. 14, 1 il.

Lerman, Leo. "American Eye," *House & Garden,* vol. 90, December 1946, pp. 120-25, 1 il.

J. D. M. "American Abroad," *Magazine of Art,* vol. 40, January 1947, pp. 21-25, 1 il.

Breuning, Margaret. "Vernal Preview," *Art Digest,* vol. 21, April 15, 1947, p. 21, 1 il.

"John Brown Series by Jacob Lawrence," *Portland Museum Bulletin,* vol. 8, July 1947, p. 2.

"New Yorkers to see Jacob Lawrence Exhibit Christmas Week," *Design,* vol. 49, December 1947, p. 15.

"Reviews and Previews," *Art News,* vol. 46, December, 1947, p. 44, 1 il.

Valente, Alfredo. "Jacob Lawrence," *Promenade,* December 1947, 1 il.

Carlson, Helen. "Inness and Some Moderns," *The* (New York) *Sun,* December 5, 1947, p. 27.

Genauer, Emily. "Jacob Lawrence War Paintings are Tragic," (New York) *World-Telegram,* December 6, 1947, p. 4.

C. B. "In the Art Galleries," (New York) *Herald Tribune,* December 7, 1947, p. 4.

Devree, Howard. "An Annual Round-Up: Jacob Lawrence," *The New York Times,* December 7, 1947, p. 16x, 1 il.

Gibbes, Jo. "Lawrence Uses War for New Sermon in Paint," *Art Digest,* vol. 22, December 15, 1947, p. 10, 1 il.

"Art: Strike Fast," *Time,* vol. 50, December 22, 1947, p. 61, 1 il.

Denvir, Bernard. "Negro Art in the United States," *London Forum,* vol. 1, Christmas 1947, p. 20, 2 il.

"Revolt from Victorian Prettiness," *Art News Annual,* no. 18, New York, 1948, p. 110, 1 il.

Evans, Walker. "In the Heart of the Black Belt," *Fortune,* vol. 38, August 1948, pp. 88, 89, 3 il.

"Art," *Time,* vol. 53, April 11, 1949, p. 57, 1 il.

M. L. "Paintings for $250," *Art Digest,* vol. 23, August 1, 1949, p. 15, 1 il.

"Vogue Presents Fifty-Three Living American Artists," *Vogue,* vol. 115, February 1, 1950, pp. 150-53, 1 il.

Sweeney, James Johnson. "Sweeney Setting his American Scene," *Art News,* vol. 49, May 1950, p. 18, 1 il.

Coates, Robert M. "In the Art Galleries," *The New Yorker,* vol. 26, October 7, 1950, p. 32.

*Louchheim, Aline B. "An Artist Reports on the Troubled Mind," *The New York Times Magazine,* October 15, 1950, pp. 15, 16, 36, 38, 4 il.

Devree, Howard. "Modern Round-Up: Record of Growth," *The New York Times,* October 29, 1950, p. 9x.

Fitzsimmons, James. "Lawrence Documents," *Art Digest,* vol. 25, November 1, 1950, p. 16, 1 il.

"Reviews and Previews," *Art News,* vol. 49, November 1950, p. 65, 1 il.

Louchheim, Aline B. "Art in an Insane Asylum," *Negro Digest,* vol. 9, February 1951, pp. 14-19. (Reprint of Louchheim, Aline B., "An Artist Reports on the Troubled Mind," *The New York Times Magazine,* October 15, 1950.)

*"Jacob Lawrence," *Ebony,* vol. 6, April 1951, pp. 73-78, 4 il.

Pearson, Ralph M. "A Modern Viewpoint," *Art Digest,* vol. 25, May 15, 1951, p. 16.

Preston, Stewart. "Diverse Moderns; Recent Work by Lawrence," *The New York Times,* February 1, 1953, p. 8x.

F. P. "Reviews and Previews," *Art News,* vol. 51, February 1953, p. 73, 1 il.

S. G. "Fifty-Seventh Street in Review: Jacob Lawrence," *Art Digest,* vol. 27, February 1, 1953, p. 17.

"Art: Stories with Impact," *Time,* vol. 53, February 2, 1953, pp. 50-51, 1 il.

C. P. [Cipe Pineles, Art Director]. *Print,* vol. 10, September 1955, p. 23, 1 il.

J. R. M. "In the Galleries: Jacob Lawrence," *Arts,* vol. 31, January 1957, p. 53, 1 il.

P. T. "Reviews and Previews," *Art News,* vol. 55, January 1957, p. 24.

Devree, Howard. "Forceful Painting," *The New York Times,* January 6, 1957, p. 15x, 1 il.

"Art: Birth of a Nation," *Time,* vol. 69, January 14, 1957, p. 82, 1 il.

Genauer, Emily. "New Exhibit Proves Art Needn't Be Aloof," (New York) *Herald Tribune,* June 6, 1957, p. 10, 1 il.

"American Struggle; Three Paintings by Jacob Lawrence," *Vogue,* vol. 130, July 1957, pp. 66-67, 3 il.

"New Work: At the Alan Gallery," *Apollo,* vol. 70, October 1959, p. 106, 1 il.

V. R. "In the Galleries: Jacob Lawrence," *Arts,* vol. 35, January 1961, p. 54.

*Wright, C. "Jacob Lawrence," *Studio,* vol. 161, January 1961, pp. 26-28, 4 il.

"Art: Bright Sorrow," *Time,* vol. 77, February 24, 1961, pp. 60-63, 3 il.

*"Jacob Lawrence," *Motive,* vol. 22, April 1962, pp. 16-24, 14 il.

Mayor, A. H. "Painters' Playing Cards," *Art in America,* vol. 51, April 1963, p. 41. (Reprinted in Lipman, Jean, *What is American in American Art* [New York: Art in America, 1963].)

"Art: Black Mirror," *Newsweek,* vol. 61, April 15, 1963, p. 100, 1 il.

O'Doherty, Brian. "Summary of Some Other Art Shows in Galleries this Week," *The New York Times,* April 20, 1963, p. 24.

Raynor, V. "In the Galleries: Jacob Lawrence," *Arts,* vol. 37, May 1963, p. 112.

"Artist Extraordinary," *Interlink* (The Nigerian American Quarterly Newsletter), vol. 2, July 1964, p. 4.

Barnitz, J. "In the Galleries: Jacob Lawrence," *Arts,* vol. 39, February 1965, p. 66.

R. B. "Reviews and Previews," *Art News,* vol. 17, February 1965, p. 17, 1 il.

W. B. "In the Galleries: Jacob Lawrence," *Arts,* vol. 40, May 1966, p. 66.

Glueck, G. "Who's Minding the Easel?: New Show at the Terry Dintenfass Gallery," *Art in America,* vol. 56, January 1968, p. 113.

R. P. "Reviews and Previews," *Art News,* vol. 66, January 1968, p. 15.

*Canaday, John. "The Quiet Anger of Jacob Lawrence," *The New York Times,* January 6, 1968, p. 26 L.

Willis, Clayton. "Jacob Lawrence's Paintings on Exhibit," *Amsterdam News* (New York), January 20, 1968, p. 16.

*"Afro-American Art: 1800-1950," *Ebony,* vol. 23, February 1968, pp. 116-22, 1 il.

G. D. "In the Galleries: Jacob Lawrence," *Arts,* vol. 42, February 1968, p. 65.

Greene, Carroll, Jr. "The Afro-American Artist," *The Art Gallery,* vol. 11, April 1968, pp. 12-25, 1 il.

*"The Black Artist in America: A Symposium," *The Metropolitan Museum of Art Bulletin,* vol. 27, January 1969, pp. 245-61.

"New Educational Materials," *Scholastic Teacher,* vol. 24, January 17, 1969, p. 17, 1 il.

Werner, A. "Black Is Not a Color," *Art and Artists,* vol. 4, May 1969, p. 15, 1 il.

"Harriet and the Promised Land," *Interracial Books for Children,* Summer 1969.

*"Painter of Life: Jacob Lawrence," *Scholastic News Time,* vol. 36, January 26, 1970, pp. 12-14, 2 il.

*Greene, Carroll, Jr. "The Black Artist in America," *The Art Gallery,* vol. 13, April 1970, pp. 1-29, 1 il.

Rustin, Bayard. "The Role of the Artist in the Freedom Struggle," *The Crisis,* vol. 77, August-September 1970, pp. 260-63.

*Lawrence, Jacob. "The Artist Responds," *The Crisis,* vol. 77, August-September 1970, pp. 266-67.

Weisberger, Bernard. "The Migration Within," *American Heritage,* vol. 22, December 1970, pp. 30-39, 9 il.

"Lawrence. Aesop's Fables," *Library Journal,* January 1971, p. 43.

"Jacob Lawrence," *Contact,* vol. 30, October 1971, pp. 20-21, 4 il.

Rumley, Larry. "Art from the Black Experience," *The Seattle Times,* November 12, 1972, p. 34.